The Letter

A Post-Impressionist

Being the Familiar Correspondence of
Vincent Van Gogh

Vincent van Gogh

Translator: Anthony Ludovici

Alpha Editions

This edition published in 2022

ISBN : 9789356718302

Design and Setting By
Alpha Editions
www.alphaedis.com
Email - info@alphaedis.com

Contents

INTRODUCTORY ESSAY ON VAN GOGH AND HIS ART.

THOUGH the collection of letters contained in Cassirer's publication, "Vincent Van Gogh. Briefe," is not a complete one, from my knowledge of a very large number of the letters which are not included in this volume, I feel able to say that the present selection is in any case very representative and contains all that is essential in respect to Van Gogh's art-credo and general attitude of mind.

For reasons into which it is unnecessary for me to enter here, it was found convenient to adopt the form of Cassirer's publication arranged by Margarete Mauthner, and my translation has therefore been made from the German (Fourth Edition, 1911). Still, with the view of avoiding the errors which were bound to creep into a double translation of this sort, I took care, when my version was complete, to compare it with as many of the original French letters as I was able to find, and I am glad to say that by this means I succeeded in satisfying myself as to the accuracy of every line from page 39 to the end.

The letters printed up to page 38, some of which I fancy must have been written in Dutch—a language which in any case I could not have read—have not been compared with the originals. But, seeing that the general quality of the German translation of the letters after page 39 was so good that I was able to discover only the small handful of inaccuracies referred to in the appendix, I think the reader may rest assured that the matter covering pages 1 to 38 is sufficiently trustworthy for all ordinary purposes.

I say that "I fancy" some of the letters which occur between pages 1 and 38 were written in Dutch; for I am not by any means certain of this. In any case I can vouch for the fact that the originals of all the letters after page 38 were in French, as I have seen them. But in this respect Paul Gauguin's remark about his friend Van Gogh is not without interest: "Il oubliait même," wrote the famous painter of négresses, "d'écrire le hollandais, et comme on a pu voir par la publication de ses lettres à son frère, il n'écrivait jamais qu'en français, et cela admirablement, avec des 'Tant qu'à, Quant à,' à n'en plus finir."[1]

Rather than disfigure my pages with a quantity of notes, I preferred to put my remarks relative to the divergencies between the original French and the German in the form of an appendix (to which the Numbers 1 to 35 in the text refer), and have thus kept only those notes in the text which were indispensable for the proper understanding of the book. Be this as it may,

the inaccuracies and doubts discussed in the appendix are, on the whole, of such slight import, that those readers who do not wish to be interrupted by pedantic quibbles will be well advised if they simply read straight on, without heeding the figures in the text. To protect myself against fault-finders, however, such readers will understand that it was necessary for me to prepare some sort of a list referring to those passages which, in the German, differed even slightly from the French original.

In the letters not included in Cassirer's publication, there are, of course, a few passages which, for obvious reasons, could never have been brought before the German or English reading public; as will be seen, however, the present letters in themselves are but more or less lengthy fragments, carefully edited by the friends of the deceased painter, while the almost complete omission of dates and other biographical information usually accompanying a volume of this sort, may also at first be felt as a rather disturbing blemish.

I would like, however, to seize this opportunity to defend Margarete Mauthner against the charge of having made a "fantastic arrangement" of these letters; for, if the person who made this charge had only been acquainted with the facts of the case, he would have known that she had done no more (at least from page 39 onwards) than faithfully to follow Emile Bernard's original arrangement of his friend's correspondence in the "Mercure de France"; and surely we must assume that Emile Bernard, Van Gogh's devoted admirer, was the best judge as to what should, or should not, appear of all that his friend had written.

With regard to dates, however, Emile Bernard does give a little more information than Margarete Mauthner; but it is very little, and it is as follows: the letters to E. Bernard from page 39 to page 73 were written during 1887; those from page 73 to page 86 were written during 1888; those from page 108 to page 112 were written during 1889, and the remainder, as Margarete Mauthner also tells us, were written during 1890. Of the letters to Van Gogh's brother, I am afraid I can say nothing more definite than that all those which occur after page 87 were written in Arles, and probably San Remy, between 1887 and 1890.

Now, postponing for a moment, the discussion of Van Gogh's actual place in the history of the art of the nineteenth century, and bearing in mind the amount of adverse criticism with which his work has met for many years, it does not seem irrelevant here to lay stress upon the fact that these letters are all *private, intimate* communications, never intended to reach the public eye. And I feel all the more inclined to emphasize this point, seeing that, to the lay student of art, as also to the art-student himself, it is often a difficult task to take the sincerity of the art-innovator for granted.

Confronted with a new technique and an apparently unprecedented conception of the outer-world—faced, in fact, by a patch of strange blood; for that is what it comes to after all—we are prone to doubt that our man is *bonâ fide.* Filled with the prejudices and prepossessions of centuries, and knowing from sad experience that the art-world is not without its arch-humbugs, we find it difficult to believe that such a strange and foreign grasp of reality could actually have been felt by the innovator in our midst. And, rather than question our own values and our own grasp of reality, we instinctively, and, as I think, very healthily, incline to doubt the sincerity of the representative of this new standpoint which is offensive to us.

In Van Gogh's case, however, we are particularly fortunate; for we possess these letters which are proof enough of the sincerity with which he pursued his calling. And, as I say, he did not write them for the press, nor did he compose them as a conscious teacher. They simply took shape quite naturally in his moments of respite, when he felt the need of unburdening his heart to some sympathetic listener; and in writing them he was as ingenuous and as unembarrassed as a child. He wrote to his brother and to a bosom friend, Emile Bernard. As I have mentioned, a good deal in these letters had to be suppressed—and very naturally too. For if this correspondence had not contained much that was of too intimate a character for publication, it is obvious that the very parts that were considered publishable, would not have had a quarter of the value which we must now ascribe to them. It is precisely because these letters are, as it were, soliloquies which Van Gogh held in the presence of his own soul, that they seem to me to be of such incalculable value to all who think and work in the domain of art, and even in the domain of psychology and morality to-day.

For everyone who is acquainted with the literature of Aesthetic, must know how poor we are in human documents of this nature, and how comparatively valueless the greater part even of our poor treasure is, when it is compared with the profound works which men who were not themselves painters or sculptors, have contributed to our literature on the subject.

Who has not been disappointed on reading Ghiberti's commentaries, Leonardo's note books, Vasari's discourses on "Technique," Antoine Raphael Mengs's treatises, Hogarth's Analysis of Beauty, Reynolds' Discourses, Alfred Stevens' Aphorisms, etc.? But who has not felt that he was foredoomed to disappointment in each case? For an artist who could express the "why" and the "how" of his productions in words would scarcely require to wield the chisel or the brush with any special power. The way in which one chooses to express oneself is no accident; it is determined

by the very source of one's artistic passion. A true painter expresses himself best in paint.

With Van Gogh's letters, however, we are not concerned with a painter who is writing a text-book for posterity, or undertaking to teach anybody his art, or to reveal the secrets of it to his fellows. The communications to his brother and his friend, printed in this volume, partake much more of the nature of a running commentary to his life-work, a Sabbath's meditation upon and contemplation of his six days' labour, than a series of technical discourses relating to his procedure and its merits. True, technical points arise, but they are merely the fleeting doubts or questionings of an expert chatting intimately with an intimate, and are quite free from any pedagogic or didactic spirit. On the other hand, however, that which he gives us, and which the others above-mentioned scarcely touch upon, is the record of his misgivings and fears concerning the passion that animated him, the value of this passion, and the meaning of his function as a painter in the midst of civilised Europe of the nineteenth century. These letters are not only a confession of the fact that he participated heart and soul in the negative revolution of the latter half of that century, they are also a revelation of the truth that he himself was a bridge leading out of it, to better and more positive things.

He touches upon these questions lightly, as is only fitting in letters that bear other tidings of a more prosaic nature, but he never can conceal the earnestness with which he faced the problems that were present in his mind, and as a stenographic report of these problems these letters make the strongest claim upon our attention.

With regard to his ultimate dementia, I have little doubt myself as to how it was brought about. As in the case of Nietzsche and many another foreign or English poet or thinker, I cannot help suspecting it was the outcome of that protracted concentration of thought upon one or two themes (the chief characteristic of all mania, by-the-bye), which he and a few other unfortunate and whole-hearted men found it necessary to practise in the midst of a bustling, changing, and feverishly restless age, if anything of *lasting* worth was to be accomplished.

Imagine a man trying to study the laws governing a spinning top in the midst of the traffic of the city, and you have a fair image of the kind of task a sincere artist or thinker undertakes at the present day, if he resolve, in the midst of the rush and flurry of our age, to probe the deep mystery of that particular part of life to which he may happen to feel himself drawn by his individual tastes and abilities. Not only is he foredoomed to dementia by the circumstance of his occupation, but the very position he assumes—bent

over his task amid the racket and thunder of the crowded thoroughfare of modern life—gives him at least the aspect of a madman from the start.

And Van Gogh himself was perfectly aware of this. For he realized that the claims which nowadays are put upon the energy of one individual concentrated seeker, are so enormous that even the complication of marriage may prove one strain too many for him. He admits that the Dutch artists married and begat children; but, he adds: "The Dutchmen led a' peaceful, quiet, and well-ordered life" (page 61). "The trouble is, my' dear old Bernard," he says, "that Giotto and Cimabue, like Holbein and Van Eyck, lived in an atmosphere of obelisks—if I may use such an expression—in which everything was arranged with architectural method, in which every individual was a stone or a brick in the general edifice, and all things were interdependent and constituted a monumental social structure.... But we, you know, live in the midst of complete *laisser aller* and anarchy; we artists who love order and symmetry isolate ourselves and work at introducing a little style into some particular portion of the world" (page 59).

And this is no empty lament; it is a plain statement of the fact that in the disorder and chaos of the present day, not only has the artist no place allotted to him, but also that the very position he tries to conquer for himself, is hedged round with so many petty obstacles and minor personalities, that his best and most valuable forces are often squandered in a mere unproductive attempt at "attaining his own." That he should need, therefore, to practise the most scrupulous economy with his strength—a precaution which in a well-ordered age, and in a healthier age, would not be necessary—follows as a matter of course.

"I should consider myself lucky," sighed Van Gogh, "to be able to work even for an annuity which would only just cover bare necessaries, and to be at peace in my own studio for the rest of my life" (page 88).

Without his brother Theodor's devotion and material help it is impossible to think without alarm of what might have become of this undoubted genius. For it must be remembered that his brother practically kept him from his Hague days in 1881 until the very end in 1890, at Auvers-sur-Oise. It is only when we think of the irretrievable loss which we owe to the fact that Monet himself had to remain idle for six months for want of money, that we can possibly form any conception of what the result would have been if Theodor Van Gogh had ever lost faith in his elder brother, and had stopped or considerably reduced his supplies, or had ever accepted his offer to change his calling (see page 129).

On the other hand, we have evidence enough in these letters to show that Vincent took this self-sacrifice on his brother's part by no means

lightly. We have only to see the solicitude with which he speaks of his brother's exhausting work (pages 127-30, 146) and of his health, in order to realize that it was no mean egoism that prompted him to accept this position of a dependent and of a protégé. In fact, if we value his art at all, it is with bated breath that we read of the cheerful and stoical manner with which for his brother's sake Vincent stopped painting for a while (page 102). But the words will bear being repeated:

"I am not so very much attached to my pictures," he says, "and will drop them without a murmur; for, luckily, I do not belong to those who, in the matter of works of art, can appreciate only pictures. As I believe, on the contrary, that a work of art may be produced at much less expense, I have begun a series of drawings" (see also page 50).

Again and again he complains of the cost of paint and canvas, and to have allowed him *carte blanche* in the purchase of these materials, the brother must, considering his circumstances, have been capable not only of very exceptional generous feeling, but of very high artistic emotion as well. For it must have been no easy matter for this employee of Messrs. Boussod and Valadon to have worked year in and year out and, without any certain prospect of recovering his outlay, to have paid these monthly bills for Vincent's keep and Vincent's work. It is true that occasionally a picture of Vincent's would sell; but in those days prices were low, and even Vincent himself was often willing to accept a five-franc piece for a study. Besides, the expenses must have been made all the heavier thanks to Vincent's inveterate carelessness and lack of order in little things, and there can be no doubt that a fair portion of the materials purchased must have been literally wasted, if not lost.

Gauguin, speaking of his meeting with Van Gogh in Arles, writes as follows:

"Tout d'abord je trouvai en tout et pour tout un désordre qui me choquait. La boîte de couleurs suffisait à peine à contenir tous ces tubes pressés, jamais refermés, et malgré tout ce désordre, tout ce gâchis, un tout rutilait sur la toile."[2]

Still both Van Gogh and his brother had an indomitable faith in the former's work—a faith which touches upon the sublime—though neither of them lived to see their highest hopes realized.

"As to the market value of my pictures," Vincent wrote (pages 8 and 9), "I should be very much surprised if, in time, they did not sell as well as other people's. Whether this happens directly or later on does not matter to me"[3] (see also page 17, line 20).

The finest words concerning this ideal brotherly relationship, however, have been written by Vincent's great friend, Emile Bernard.

"Mais ce que je veux dire, avant tout," says Bernard, "c'est que ces deux frères ne faisaient pour ainsi dire qu'une idée, que l'un s'alimentait et vivait de la vie et de la pensée de l'autre, et que quand ce dernier, le peintre, mourut, l'autre le suivit dans la tombe, seulement de quelques mois, sous l'effet d'un chagrin rare et édifiant."[4]

Thus Theodor and Vincent died, perhaps hoping, but little believing that Van Gogh's present triumph would ever be realized. And, indeed, even to the calm and reflecting student of art to-day, there must be something surprising, something not altogether sound and convincing, in this stupendous leap into fame which the work of this poor, enthusiastic, and thoughtful recluse, has made within recent years. If the means or the measure for placing him had been to hand, if all this posthumous success had been based upon a definite art-doctrine which knew what to select and what to leave aside, nothing could have been more imposing than this sudden exaltation of one whom a former generation had spurned. But who would dare to maintain for a moment that Van Gogh's present position is in itself a proof of his value as an artist?

It is an empty illusion to suppose that history *necessarily* "places" a man, or even a whole age, and gives to both their proper level. What history has shown and probably will continue to show is, that whereas time very often elevates true geniuses to the dignity which is their due, and confers upon them the rank that they deserve, it also certainly raises vast numbers to the position of classics, who never had a tittle of a right to that honour, and frequently passes over others in silence who ought to have had a lasting claim upon the respect and appreciation of their fellows. Such things have happened so often, and sometimes with such a disastrous effect, that one can but feel surprised at the almost universal support that the doctrine of the infallibility of posterity enjoys.

All posthumous fame, however, should be weighed in relation to the quality of the period that concedes it, and before we concur too heartily with the verdict of an age subsequent to the man it lionises, we ought, at least, to analyze that age and test its health, its virtues, and its values.

The fact that Van Gogh's pictures are now selling for twice as many sovereigns as he, in his most hopeful and sanguine moments thought that they would realize in francs, is the most deceptive and the most misleading feature about his work. In any case it should neither prepossess us in his favour, nor prejudice us against him. In a world governed largely by the commercial principle which places quantity before quality, at a period in history when journalism with all its insidious power can, like the famous

Earl of Warwick, make and unmake kings at will—finally, on a continent in which all canons in respect of right living, religion, art, morality, and politics, have been blasted to the four winds, what does it signify that a work of art which thirty years ago was not thought to be worth 25 francs, now sells for £200 sterling? It signifies simply nothing whatsoever. Would anybody venture to assert that everything which to-day is selling at 200 times the price at which it was selling thirty years ago, is on that account worthy of particular admiration and respect—I mean, of course, from people of taste, not from hawkers, pedlars, and chapmen?

A vast and unprecedented revolution has been convulsing the art-world for almost a century now, a revolution in which men like Gauguin, Van Gogh, Cézanne, Rodin, and others, have fought like Titans. Who has ever heard of a revolution enduring for almost a century? Even the Grand Rebellion lasted only for six years. And this revolution of art has seen its heroes and its traitors, its kings, and its usurpers, its romance and its squalor—all beneath the very nose of the layman, all beneath the very walls of his fool's paradise, without his ever having suspected that something even significant was brewing.

For art is always the expression of the most sensitive men of an age. They, the artists, are the first, by their movements and by the manner in which they garner their treasure, to prophesy meteorological changes of a nature vast enough to shake even the layman into a state of gasping wonder. But, as a rule, it is only when these highly sensitive men have manifested their signs, and have more or less depicted the first lightning flash of the tempest that is imminent, that the sky really does become dark and overcast—patently overcast even to the layman's eyes—and that the storm which they felt was coming actually begins to rage in the concrete world of politics and of national life. And then the pictures, poems, and parables already stored away, classified and catalogued in public museums, are but the crystallized harbingers of a fact that has become patent to all.

The general truth that nearly all the principal figures in this Grand-Rebellion Drama were themselves innovators, renovators, and subverters, does not in itself justify us in summarily disposing of them as noisy revolutionaries and nothing more. One can revolt against sickness in an age of sickness, and assume the title of a revolutionary or a rebel with both pride and dignity. On the other hand, a resentful valetudinarian, who feels rebellious at the sight of sleek, fragrant and rosy healthiness, may also claim the title "revolutionary"; but woe then to the age that allows itself to be lured over to his side by his intellect and his art.

It is important, therefore, that we should know with whom we are dealing.

We are aware that in the majority of cases all the noise of this art-revolution has been concentrated around questions of technique. The purpose of art was tacitly assumed to be to obtain as faithful a transcript as possible of nature and of reality, pure and simple—not nature linked up with a higher idea, or reality bathed in the atmosphere of a love that transcended mere actualities—but simply nature and reality as they were felt by anybody and everybody. And the milestones along the highway covered by this revolutionary band, do not mark the acquisition of new passions or new loves, but rather the adoption of new technical methods and mannerisms for accomplishing this transcript in ever more perfect and more *scientific* ways. Nature with its light and its atmospheric effects roused men like Manet and his friends to heroic deeds of determination. Peasants, "innocent" and "unsophisticated," seemingly belonging to nature and not to town or "artificial" life, were included in the category nature, from which it was legitimate to make a transcript. Café scenes, scenes of town life, glimpses "behind the' scenes," were included in the category reality, provided their "artificiality" and "unnaturalness" were mitigated by a certain "character" of which it was also legitimate to make a transcript. And all this was done, not because the peasant or the scenes from town life were linked up with any higher purpose or any definite scheme of life which happened to fire the hearts of the painters of last century; but because, as a matter of fact, all life-passions, all life-schemes were at an end, and anything was good enough, picturesque enough, trivial enough, for these artists (whose general scepticism drove them to technique as the only refuge), to tackle and to try their new technique, their new method, or new watchword upon. Light, the play of complementaries, the breaking up of light, the study of values!—little things please little minds!

It was these preoccupations that usurped the place of the rapidly vanishing "subject" in pictures. But what was the subject? What part had it played? It is true that the subject picture in Manet's time was rapidly becoming a mere farce, an empty page filled arbitrarily with any sentiment or mood that happened to be sufficiently puerile, or at least sufficiently popular. But it had had a noble past. It had had a royal youth. The subject picture was merely the survival of an age when men had painted with a deep faith. It was the last vestige of an historical period in which men had been inspired to express their relationship to life by something higher and greater than both themselves and their art. In fact, it had always flourished in periods when humanity had known of a general direction, a general purpose in life, and of a scheme of life which gave their heart-beats and their breath some deeper meaning than they have at present.

The degeneration of the subject picture, then, into a mere illustration of some passing event or ephemeral sentiment, had a deeper significance

than even its bitterest enemies recognized. For while they, as new technicians seeking light and complementaries and values, deplored the spiritless and uninspired "oliographs" of their academical contemporaries, they completely overlooked the deeper truth; their artistic instincts were not strong enough to make them see that the spiritless and uninspired subject picture was the most poignant proof that could be found of the fact that mankind no longer possessed, to any passionate or intense degree, that which made the subject picture possible—that is to say, a profound faith in something greater and more vital either than the artists themselves or their art, something which gave not only art but also life a meaning and a purpose.

This, as I have pointed out elsewhere, was the great oversight of the revolutionary movement in Art of the second half of the nineteenth century. In abusing the degenerate "subject" picture, these innovators were simply inveighing against a pathological symptom. In saying the subject did not matter, they deliberately scouted the responsibility of eradicating or even of confronting the evil; while in concentrating upon technique and in finding their inspiration in such secondary matters as the treatment of light, values, and complementaries, besides revealing the poverty of their artistic instincts they merely delayed the awakening which was bound to come and which already to-day is not so very far distant—the awakening to the fact that the artist, the architect, the painter, the poet, and the preacher, are bankrupt unless some higher purpose and direction, some universal aim and aspiration, animate their age, inspire them in their work, and kindle in them that necessary passion for a particular type of man, on which they may lavish their eloquence, their chromatic, musical, architectural, or religious rhetoric with conviction, power, and faith.

Where does Van Gogh stand in this revolutionary drama which I have attempted briefly to sketch in the above lines?

Without esteeming him nearly so highly as many of his most enthusiastic admirers do, and without sharing in the least in that hysterical exaggeration of the value and beauty of his works which has characterized the attitude of large numbers of his followers on the Continent—an exaggeration which, as I shall show, he would have been the first to deprecate and to condemn—I must still confess that, as an impressionist, *i.e.*, as a revolutionary of the 'eighties who, to my mind, *strove to surpass impressionism*, as also so-called post-impressionism, he is a painter for whom I feel a much greater respect than I can feel for Manet, Monet, Renoir, Degas, and Whistler. Let me make it quite plain that I realize the superiority in some respects of the latter's art-forms; let me emphasize the fact that in my opinion Van Gogh was by no means so mature in his procedure as any one of these artists (save, perhaps, in so far as his drawing far excelled

Renoir's); but that his aims were higher and more vital, that he realized more keenly what was wrong and what was desirable, that he was a thousand times more profound than his predecessors—of all these things, after careful consideration, and I must admit grave doubts, I have at last grown quite convinced.

Before proceeding with my argument, let me lay stress on the point that I feel very little sympathy whatever with any of these impressionists, *art-form-maniacs*, and their followers inasmuch as they obscured the issues at the very moment—half way through the last century—when the issues were growing so plain that they *must* have found a solution sooner or later. But, if we are going to speak of preferences, if in a gingerly manner we are going to put on gloves and draw out from among this crowd the men whom we feel we can tolerate most readily, then, from the sculptor Rodin to his friend Renoir, of all the names that are now household words in the impressionistic and post-impressionistic movement of the late nineteenth century, I for my part, certainly select Van Gogh and, perhaps a little way before him, his friend Gauguin, as the only two whom I can contemplate with equanimity—not to speak of approval.

In judging Van Gogh, one of the critic's greatest difficulties is, in the first place, to see a sufficient number of his pictures; for he passed through so many phases that isolated examples of his work may prove merely misleading. Now, thanks to the Post-Impressionist Exhibition of 1910-1911 in London, the Sonderbund Austellung in Cologne (1912), and a visit to Amsterdam, I have been able to see about 200 of Van Gogh's paintings, and about a quarter as many drawings; but when one remembers that the largest exhibition of his work which has ever been held contained some 450 pictures alone, not to speak of drawings, it will be seen that to be acquainted with 200 of his works is a long way from possessing a complete knowledge of what he achieved. Still the specimens I have seen I believe to have been thoroughly representative, and in any case sufficient to warrant my forming an opinion as to his merits.

Van Gogh died when he was only thirty-seven years of age, and Emile Bernard reminds us that though he always used to draw, he really did not give his attention wholly to painting until the year 1882—that is to say, when he was fully twenty-nine years old. About this time he writes to his brother: "In a sense I am glad that I never learned to paint.... I really do not know how to paint. Armed with a white panel I take up a position in front of the spot that interests me, contemplate what lies before me, and say to myself, 'that white panel must be turned into something!'" And concerning two studies finished at this period, he says: "I feel quite certain that on looking at these two pictures, no one will ever believe that they are the first studies I have ever painted" (pages 15 and 4).

It is true that in the early 'eighties he studied a little with Mauve, who was a distant relative, and later on spent some time at the Academy at Antwerp; but, on the whole, like Gauguin, he was self-taught, and when we reckon the number of years during which this self-tuition lasted, we can but be amazed at the result, and believe him when he says that painting was in his very marrow (page 16).

A still more remarkable fact about Van Gogh is, however, that during the last eight years of his life—the only years, that is to say, in which he may really be said to have devoted himself entirely to painting, whether at the Hague, Drenthe, Nuenen, Antwerp, Paris, Arles, San Remy, or Auvers-sur-Oise—he practically epitomised in his own work the whole of the development of modern painting, from the academical manner of his own day, to a style which I maintain was on the point of bearing him far beyond the impressionists and so-called post-impressionists. And when I say "far beyond the impressionists and so-called post-impressionists," I do not mean it in the accepted sense of this phrase, I do not mean that with Gauguin he promised to land in any of the futile absurdities with which those artists that were hung beside them provoked the mirth of London at the famous exhibition at the Grafton Galleries in 1910-1911. I mean it in this case as something peculiar to Van Gogh and Gauguin alone—something which I shall explain in due course and which I regard as valuable and worthy of a more sound artistic instinct than that possessed by all their contemporaries.

I have myself seen pictures which I could not help thinking must have been painted in Van Gogh's academic period; Meier Graefe even thinks that Van Gogh's work of this period is likely to rise in public esteem; I have little doubt, therefore, that Van Gogh did go through an academic stage, however short or however undistinguished it may have been.[5]

And as for his purely impressionistic period, pictures of this stage of his development abound. "The Moulin de la Galette," and a still-life, "Basket and Apples," in the possession of Frau A. G. Kröller, the "View' of Paris from Montmartre," belonging probably to the family, and the wonderful "Apples in a Basket" dedicated to his friend Lucien Pissaro, in the possession of Frau Kröller—all seem to belong to this period; and they are by no means incompetent or unworthy examples of the school of which they are examples.

At this stage he had the same contempt as all modernists had for academicians, and we find him endorsing Jacques' words that they are "mere illustrators!" It is now that he feels that light, and truth, and transcripts of nature matter tremendously. He says he has done with "grays" and with Mauve and Israels as well (page 48).

He enters heart and soul into a study of nature—no pains are too great, no sacrifices too heavy, provided only that he may become "absorbed in' nature," and thoroughly at ease as her interpreter. Possessed as he was of a remarkable gift of observation, nature fortunately did not take long to tell him all that she has to tell the truly instinctive artist; for a man who could paint that still-life, "Apples in a Basket," dedicated to Pissaro, and the still-life "A Statuette, a Rose and' Books," belonging, I believe, to Van Gogh's family—not to speak of dozens of other marvels of observation, such as the "Chestnut in Bloom," belonging to Frau Kröller, in which the essential character of the tree is beautifully seized by the happiest of conventions—would necessarily be a rapid and courageous learner of all that nature can teach, and would soon become conscious of having reached that decisive Rubicon, the imperative crossing of which means one of two alternatives—either the continuation of the old attitude to nature, which at this stage becomes mere slavery and no longer discipleship, or the mastering of nature which is the first step that reveals the mature artist of sound instincts.

Van Gogh writes: "I do not wish to argue studying from nature, or struggling with reality, out of existence. For years I myself worked in this way with almost fruitless and in any case wretched results. I should not like to have avoided this error, however.

"In any case I am quite convinced that it would have been sheer foolery on my part to have continued to pursue these methods—although I am not by any means so sure that all my trouble has been in vain" (p. 30).

So far, then, Van Gogh's sole excuse—and it is an adequate one—for having concerned himself wholly with such subordinate things as art-forms and nature transcripts, is that he was a learner. A time comes, however, when in the case of the mature artist, we must take technical competency for granted, and graybeards, as many of the impressionist sculptors and painters grew to be, who continue to concentrate upon technical questions and to regard them as ends in themselves, merely reveal the fact that they never were artists at all. In this respect I cannot help quoting some fine words of Gauguin's. Writing to Charles Morice in April 1903, he said:

"Nous venons de subir, en art, une très grande période d'égarement causée par la physique, la chimie, la mécanique et l'étude de la nature. Les artistes, ayant perdu tout de leur sauvagerie, n'ayant plus d'instinct, on pourrait dire d'imagination, se sont égarés dans tous les sentiers pour trouver des éléments producteurs qu'ils n'avaient pas la force de créer."[6]

The reader who is familiar with my aesthetic views, will understand that I do not regard "la physique, la chimie et la mécanique," as sufficient causes of this state of affairs; nevertheless Gauguin adds that the painters of

this "période d'égarement," had lost their instincts, and here, of course, I am with him.

The fact, however, that a painter or a sculptor has *not* lost his instincts is not sufficient to reform the civilization or the culture in which he lives. A still greater and more powerful artist must set to work first, and he is the legislator. The most a painter or a sculptor of sound instinct can do, is to recognize the lack of the great legislator, and reveal by his work and by the things upon which he concentrates his mind, that he realizes where the fault lies.

Now I maintain that Van Gogh and Gauguin took up this position.— But I am anticipating.—Van Gogh passed through another stage before he reached this final one. It suddenly flashed across his mind that he had something to bestow, something to bequeath, and that an artist's life was not all taking, robbing, or copying. He felt a richness in him which bade him dispense and no longer receive.

He writes: "One begins by plaguing oneself to no purpose in order to be true to nature, and one concludes by working quietly from one's own palette alone, and then nature is the result" (page 30).

And again: "I often feel sorry that I cannot induce myself to work more at home from imagination. Imagination is surely a faculty one should develop" (page 44).

And listen to this! "How glad I should be, one day to try to paint the starry heavens, as also a vast meadow studded with dandelions in the sunlight. But how can one ever hope to succeed in doing these things unless one resolves to stay at home and to work from imagination?"

He also begins to throw off the technique of transcript painting. He recognizes that chiaroscuro with its essential "study of values," is part of the equipment of the mere slavish transcriptist, and he writes: "It is impossible to attach the same importance both to values and to colours. Theodore Rousseau understood the mixing of colours better than anyone. But time has blackened his pictures, and now they are unrecognizable. One cannot be at the Pole and at the Equator at once. One must choose one's way; at least this is what I hope to do, and my way will be the road to colour" (page 137).

And again: "Tell him (Seurat) it is my most fervent desire to know how to achieve such deviations from reality, such inaccuracies and such transfigurations, that come about by chance. Well yes, if you like, they are lies; but they are more valuable than real values" (page 23).

These are the thoughts of his most prolific period—the period during which he produced perhaps all his most striking pictures—the last three years of his life. Such pages of beauty as the "Orchard in Provence," belonging to Madame Cohen Gosschalk-Bonger, "A Street in Arles," in the possession of the Municipal Museum at Stettin, "A Street in Auvers," belonging to A. von Jawlensky, Munich, hail from this period, as also "The Lawn," probably in the possession of the family—a finished masterpiece of beauty; "The Sunset" belonging to Frau Tilla Durieux-Cassirer—excellent; and a number of other landscapes belonging to Frau Kröller, Frau Mauthner, Frau Cohen Gosschalk-Bonger, etc.—all of great splendour and mastery.

The fact that he was never able to work successfully from imagination *alone*, proves nothing against the art of working from imagination. I have heard some artists argue as if their individual incapacity to produce great work from imagination were a sufficient proof of the fallacy of the principle. Such argumentation is, of course, beneath contempt. On such lines any incompetence, impotence, ignorance, or incapacity, could be glorified and exalted. Van Gogh, however, is more honest. He says working from imagination is an "enchanted land" (page 112). Although he recognizes the desirability, the superiority, of such methods, he feels that he is not good enough for them. He says: "Others may be more gifted for the painting of abstract studies, and you [Bernard] are certainly one of these, as is also Gauguin." And he concludes by saying that when he is older he too may do the same.

All his imagination could do, therefore, was to introduce something into his landscapes and studies that made them more than mere transcripts, that constituted them new gifts rather than repetitions, placed in the hand of the grateful public. And this "something" which he introduced, was the step to higher things, which I believe to be the chief characteristic of his final period—the period at the very threshold of which he unfortunately met with his tragic end.

But before I proceed let me explain why I use the adjectives "beautiful, excellent, splendid, masterful" in regard to these pictures. I am not in the habit of lavishing epithets of this vague description indiscriminately upon works of art. A vague adjective is a wonderful thing to help lame arguments over stiles. It is an indispensable helpmeet when one is not quite clear concerning any particular thing: but in regard to Van Gogh, this is not precisely my position. Not so much for my own sake, then, as for the sake of clarity in these questions, in which difficulties are so often smoothed over with empty phrases, it would seem desirable to explain why I speak of "beauty," "mastery," "excellence," in regard to these pictures of what, in my opinion, may be called Van Gogh's penultimate

period, and which all critics, save myself, regard as belonging to his ultimate or post-impressionist period.

In the first place, then, let me pronounce this fundamental principle, as far as I personally am concerned—that there is no beauty, no mastery, and no excellence, which cannot in the end be interpreted in the terms of humanity. There is no such thing as beauty *per se*, mastery *per se*, and excellence *per se*. All these qualities can ultimately be traced to man and to man's emotion; and without man I maintain that such qualities would cease to exist on earth.

A beautiful poem is one that can be linked up rapidly or by degrees, consciously or unconsciously, with things which are desirable in humanity, or in a certain kind or part of humanity. The poem that praises Pity in rhythmic cadence, for instance, will charm the Christian of the twentieth century; for him, Pity is a desirable attribute of the modern human creature, and rhythm is a convincing and commanding art-form in which to cast a desirable thought. On the other hand, it would either revolt the pagan or leave him indifferent, while he might regard it as a sacrilegious act to squander such a precious art-form as rhyming verses upon so futile a subject.

All beauty, then, in the end, is human beauty, all ugliness is human ugliness. No healthy people of the world have ever considered youth (I do not mean infancy) in any manifestation of nature, as ugly; because youth is the sure promise of human life and of a multiplication of human life. On the other hand, no healthy people have ever considered ulcers, gangrenous limbs, or decay in any form, as beautiful; because ulceration, gangrene, and decay, are the end of human life and the reduction of it. It is true that the "beautiful consumptive," the "love of consumptives," the "captivating cripple," are notions which can be found in Bulwer Lytton and George Eliot, not to speak of a host of minor English writers. But then, let us remember from what part of the world they hail—from the most absurdly sentimental, over-Christianized, and over-Puritanized country on earth—England. But the whole of North-Western Europe is now quite able to vie with England in this sort of nonsense, otherwise the Eugenic Society, which ought to be superfluous, would not require to be so active.

But all this by the way. The beauty, mastery, and excellence of Van Gogh's penultimate period, then, in my opinion, is twofold. Its content is beautiful and its form is beautiful. Its content is only just beginning to be beautiful, because we must remember that this is the work of a man who started in a school that scorned content. But is it not written that "there is more joy in heaven over one sinner that repenteth than over ninety-nine just persons which need no repentance"? And the beauty of his content is,

that it is turning ever more and more definitely towards humanity. It is true that the importance of the content in general is only creeping into his works; but the little of it that there is, is human. No longer negative to man, he begins to introduce human moods into his landscapes, and with human virtues he anthropomorphizes the ground, the trees, the sky, and the distance. There is as much difference between his work now and the work of his impressionistic days as there is between these two descriptions of the rising sun: (1) "The yellow sun ascends into a pink and pale yellow sky which fades away into watery green and finally into a pure azure," and (2), "Rosy-fingered dawn stands tip-toe on yonder hill."

He himself writes concerning a certain study: "My desire was to paint it in such a way that the spectator must read and sympathize with the thoughts of the signalman ... who seems to say: 'Oh, what a gloomy day it is!'" (page 8).

And again, in regard to the other study, he writes: "While working upon it, I said to myself: 'Do not put down your palette before your picture seems to partake of the mood of an autumn evening, before it is instinct with mystery and with a certain deep earnestness'" (page 14). See also the passage about Provence on page 109.

It is now, too, that he writes to his friend Bernard: "I have painted seven studies of corn; *unfortunately quite against my will*,[7] they are only landscapes" (page 75), and that he feels sympathy with a soldier who prefers a landscape to the sea, because the former is inhabited (page 85). This alone is already a sign that he is turning his back on the sentimental and negative love of landscape as landscape, peculiar to the modern English, French, and Germans, inspired by Rousseau and Schiller—that love of landscape in which man or the hand of man is entirely absent.

With regard to the beauty of his technique in the pictures of this period, the characteristic I chiefly admire in them is their gradual glorification of colour, and neglect of values. But why should one admire colour more than values? In the first place it should be remembered that technique is important only as a means of betraying how a man *approaches* and *deals with* reality; while all the virtues of a good technique will once more be traceable to human standards, and be human virtues. Now the technique which places colour above values, is admirable for three reasons: first, because inasmuch as its results are simpler and more definite than those of the "values-technique," it implies a much more *masterful* grasp of reality; secondly, since its results betray far less compromise and *blended*, grey, or democratic harmony, than those of the values-technique, it implies a much *braver* and less tolerant attitude towards reality; and, thirdly, because its results are so much more luminous and more bright than those of the

values-technique, it betrays a much greater love of sunshine, a much more hearty yea-saying and positive attitude towards life. And these reasons are independent of the fact that the painting of both Greece and Egypt in their best period are based entirely upon colour and line technique free from all values and chiaroscuro.

Compare Van Gogh's pictures of this period with any of those ridiculously funereal fiascos produced by the Glasgow school within the last twenty-five years, and you will be convinced of the difference between the bright, laughing, yea-saying attitude to life, and the dark, gloomy, negative, churlish, Puritanical, and, in many respects, essentially British attitude to life.

How sincere and how deep Van Gogh's love of colour was at this period may be judged from a note written in August 1887 to his brother. He says: "I am at work upon a portrait of our mother; as I could no longer endure the sight of the black photograph. I do not wish to possess black photographs, and yet I certainly wish to have a portrait of our mother."[8]

The fact that, occasionally, his whole-hearted devotion to colour led him to produce what I cannot help regarding as an absolute failure, cannot, of course, be denied. More than once, at Cologne and Amsterdam, I was conscious in the presence of some of his pictures of being before a man who was trying to enjoy the glory of fireworks at midday, under a brilliant sun, and the result was naturally disappointing. I cannot, however, say that I had this feeling often. By far the worst examples of such failures (although I am sure their fanatical owners do not think so) are the "Cornfield with the Reaper," belonging to Frau Kröller, the "Sunflower against a Yellow Background," belonging to Frau Cohen Gosschalk-Bonger, and "A Cornfield in Sunshine," at the Amsterdam Museum of Modern Art.[9]

And now I am going to express what will perhaps seem to many the most daring of all the views advanced in this essay, the view that Van Gogh, towards the end, became quite positive not only in his attitude towards life itself, but above all in his attitude towards man. After much tribulation, and the gravest and most depressing doubts, he at last realized this fundamental truth, that art, sound art, cannot be an end in itself, that art for art's sake is simply the maddest form of individualistic isolation—not to use a less sonorous but more drastic term—and that art can find its meaning only in life, and in its function as a life force. The highest art, then, must be the art that seeks its meaning in the highest form of life. What is the highest form of life? Van Gogh replies to this question as emphatically and uncompromisingly as every sane and healthy artist has done in all the sanest and healthiest periods of history. He says "Man."

Now all that he has acquired—art-forms, technique, stored experience, practised observation—is but a means, a formidable equipment which he is deep enough, artist enough, human enough, to wish to lay at the feet of something higher. Now his storehouse of knowledge becomes an arsenal which he consecrates solemnly to the service of a higher cause and a higher aim than the mere immortalizing of "decorative pages of colour"—"interesting and strong colour-schemes" and "exteriorisations of more or less striking impressions." When these things are pursued as ends in themselves, as they were by the Impressionists and the Whistlerites, they are the signs of poverty, both of instinct and intelligence. They are also signs of the fact that the mere craftsmen, the simple hand-workmen, or the mere mechanic—in other words, the proletariat of the workshop, has been promoted to the rank of artist, and that matters of decoration, technique and treatment (which are fit subjects for carpenters, scene-painters, and illustrators to love and to regard as the end of their mediocre lives) have usurped the place of higher and holier aims.

In about as many years as it takes some painters to learn their palette, Van Gogh had learnt the great and depressing truth at the bottom of all the art of his age—the truth that it was bankrupt, impoverished, democratized, and futile. Divorced from life, divorced from man, and degraded by the great majority of its votaries, art was rapidly becoming the least respected and least respectable of all human functions.

He realized that art was an expression of life itself, that pictorial art was an expression of life's satisfaction at her passions become incarnate. All expression is self-revelatory. Pictorial art, then, is the self-revelation of life herself looking into her soul and upon her forms. It is life pronouncing her judgment on herself. Alas! it is less than that: it is a certain kind of life pronouncing its judgment on all life. Where life is sick and impoverished, her voice speaking through the inferior man condemns herself, and paints herself bloodless and dreary, probably with a sky above depicted in a lurid and mysteriously fascinating fashion, calculated to make the earth seem gray and gloomy in comparison. Where life is sound and exuberant, her voice, speaking through the sound man, extols herself and paints herself in bright, brave colours, which include even bright and brave nuances for pain and the like.

The sound, healthy artist, then, once he has attained to proficiency in his *métier*—a result which, if he be really wise and proud, he will not attempt to accomplish before the public eye as every one is doing at present— naturally looks about him for that higher thing in life to which he can consecrate his power. His passion is to speak of life itself, and life in its highest manifestation—Man. But, alas, whither on earth must the poor

artist turn to-day in order to find that type which would be worthy of his love and of his pictorial advocacy?

Is the hotch-potch, democratic, democratized, hard-working, woman-ridden European a subject to inspire such an artist? True, he can turn to the peasant, as many artists, and even Van Gogh himself, did. At least the peasant is a more fragrant and nobler type than the under-sized, hunted-rat type of town-man, with his wild eyes that can see only the main chance, with his moist finger-tips always feeling their way tremblingly into another's hoard, and with his womenfolk all trying to drown their dissatisfaction with him by an endless round of pleasure and repletion; but, surely there is something higher than the peasant, something greater and nobler than the horny-handed son of toil?

Gauguin and Van Gogh knew that there was someone nobler than the peasant. But the tragedy of their existence was that they did not know where to find him.

Fortunately for himself Van Gogh died on the very eve of this discovery. Gauguin suffered a more bitter fate than death; he went searching the globe for a nobler type than his fellow-continentals, at whose feet he might lay the wonderful powers that nature, study, and meditation had given him. But in doing this he was only doing what the whole of Europe will soon be doing. The parallel is an exact one. The prophecy of the artist will be seen to have been true. And Gauguin's search for a better type of humanity is only one proof the more, if such were needed, of the intimate relationship of art to life, and of the miraculous regularity with which art is always the first to indicate the direction life is taking.

I have shown how, from a negative and futile impressionist, Van Gogh became more and more positive and human in his content, and ever more positive, brave and masterly in his technique, and that this healthy development naturally led him to the only possible goal that lies at the end of the path he had trodden—Man himself.

In 1886 he writes to Bernard: "I want to paint humanity, humanity and again humanity. I love nothing better than this series of bipeds, from the smallest baby in long clothes to Socrates, from the woman with black hair and a white skin to the one with golden hair and a brick-red sunburnt face" (page 85).

At about the same time he writes to his brother: "Oh, dear! It seems' ever more and more clear to me that mankind is the root of all life" (page 89); and "Men are more important than things, and the more I' worry myself about pictures the colder they leave me" (page 131).

But the finest words in all these letters, words which at one stroke place Van Gogh far above his contemporaries and his predecessors, at least in aim, are the following: "I should like to prepare myself for ten years, by means of studies, for the task of painting one or two figure pictures ..." (page 152).

In his heart of hearts, however, Van Gogh was desperate. There can be little doubt about that. Not only did he feel that his was not, perhaps, the hand to paint the man with the greatest promise of life; but he was also very doubtful about the very existence of that man. Not only did he ask: "But who is going to paint men as Claude Monet painted landscape?" (page 103); he also shared Gauguin's profound contempt of the white man of modern times.

Indeed, what is his splendid tribute to Christ as a marvellous artist, a modeller and creator of men, who scorned to immortalize himself in statues, books, or pictures (pages 65 *et seq.*) if it is not the half-realized longing that all true artists must feel nowadays for that sublime figure, the artist-legislator who is able to throw the scum and dross of decadent civilizations back into the crucible of life, in order to mould men afresh according to a more healthy and more vigorous measure? The actual merits of Christianity as a religion do not come into consideration here; for Van Gogh was not a philosopher. All he felt was simply that craving which all the world will soon be feeling—the craving for the artist-legislator, which is the direst need of modern times. For, in order that fresh life and a fresh type can be given to art, fresh vigour and a fresh type must first be given to life itself.

Personally, although I am prepared to do all honour to Van Gogh for having been profound enough and brave enough to come face to face with the tragic dilemma of modern art and modern times, I must say that I am almost inclined to share his own doubts as to whether his was precisely the hand to limn the man of great promise even if he could have found him.

Only fanatical disciples could praise and value his figure pictures to the extent to which they have been praised and valued; for in all but one or two cases, they are, in my opinion, the most incompetent and the most uninviting examples of his art.

Of thirty-eight figure-pictures of his which I myself have seen, two only pleased me a little ("Old Man Weeping," probably in the possession of the family; and "An Asylum Warder," belonging to Frl. Gertrud Müller of Solothurn), and one ("Fair Girl's Head and Shoulders," probably in the possession of the family)[10] pleased me so exceedingly that I would willingly give all the rest for it. It is a most genial piece of work, mature and rich in conception, and full of a love which will come to expression.

Nothing obtrudes in the technique. Indeed, the means seem to be so well mastered that one feels not the slightest inclination to consider them; while the content is so eloquent of the sleek, smooth bloom of youth, and of the half-frightened eager spirit of the young girl who is just beginning to see and to realize who she is and where she is, that this picture alone would make me hesitate to say definitely that Van Gogh could not have achieved his ideal if only he had lived, and if only he had found the type whose pictorial advocacy he might have undertaken.

Here in this picture, all the dramatic effect of budding womanhood, of which Schopenhauer spoke so scornfully, is concentrated into a head and a pair of shoulders. All the mystery and charm of mere potentialities, undefined and still untried, is told in a thrilling and fairy-like combination of lemon yellow, black, Prussian blue, and the most delicate of pinks. The freshness is that of an old Dutch master like Johannes Hannot, for instance, who could paint fruit to look cold and raw on a pitch-black ground.[11] This virgin, too, like all virgins, is cold and raw—and the effect is due to the masterly and almost devilish skill with which her qualities have been marshalled in her portrait, against a pitch-black ground.

It is a wonderful work.[12] Maybe it stands as the only justification of all Van Gogh's otherwise overweening aspirations. In any case it makes me feel that if he had lived, he would have learnt to regret even more than he already did, that no artist-legislator existed to inspire his brush and give his art some deeper meaning.

With regard to the rest of his figure work, I can only say I am unsympathetic. And to all those who may accuse me of Philistinism and the like for my refusal to agree with the extravagant encomiums they lavish upon his figure pictures, I can only reply by pointing to Van Gogh's own modest and very sensible words: "Any figure that I paint is generally dreadful, even in my own eyes. How much more hideous must it therefore be in the eyes of other people" (page 69).

And now what did the admirable Gauguin have to do with all this? What part did he play in this final development of his friend's genius and in directing his brother artist's last thoughts and hopes?

We do not need to be told, we feel sure from our knowledge of the two men's work, that Gauguin played a great part in Van Gogh's life at this time. We also know that Gauguin was an older, more able, and more experienced painter than the Dutchman, with a personality whose influence is said to have been irresistible.

It was in vain that Van Gogh tried to hold him at arm's length. It was in vain that he pointed to the narrowness of Gauguin's forehead, which he

held to be a proof of imbecility; in the end he had to yield, and was, as Gauguin declares: "forcé de me reconnaitre une grande' intelligence."[13]

"Quand je suis arrivé à Arles," says Gauguin, "Vincent se cherchait, tandis que moi, beaucoup plus vieux, j'étais un homme fait.... Van Gogh sans perdre un pouce de son originalité, a trouvé de moi un enseignement fécond."[14]

And Van Gogh was as ready to admit this as we are compelled to recognize its truth. Writing to Albert Aurier, he once said: "Je dois beaucoup à' Paul Gauguin." But his latest and best work, as also the ideals and aims of his last years constitute the most convincing evidence we have of the great influence Gauguin exercised over him, and although the older man was ready to acknowledge that the seeds he sowed in Van Gogh fell upon "un terrain riche et fécond," it is impossible to overlook the great value of these seeds.

For, who was this magician, the painter of those sublimely beautiful canvases "L'esprit veille," "Portrait de M. X."[15] and "Enfants."[16]

He was a man who had felt more keenly than any other European painter of his day the impossibility of consecrating his powers to the exaltation and glory of the modern white man with whom he was "fatally' contemporaneous." He was a deep and earnest thinker who was both clear and brave enough to confront even a tragic fact. And there can be no doubt that comparatively early in life he came face to face with the truth that the modern European and his like all over the globe, could not and *must not*, be the type of the future. Anything rather than that! Even black men and women were better than that—cannibals, idolators, savages, anything! And this parched thirst for a nobler and more positive type drove him like a haunted explorer all over the world, until at last he thought he had found what he wanted. It was an illusion, of course, and he would probably have admitted this; but it was the love and not the hatred of man that drove him even to that error.

Charles Morice ascribes Gauguin's lust of travel to the nature of his origin. He argues that inasmuch as Gauguin's father was a Breton and his mother a Péruvienne, the great painter was born with the desires of two continents already in his soul—a fact which somehow or other Morice links up with Gauguin's visit to the Marquesans and the Tahitans.

But, probable as it may be that Gauguin's double soul contributed greatly to his ability for making a clear-sighted analysis and condemnation of Europe, it can scarcely be regarded as the principal, or even as the partial cause of his visit to the Marquesas Isles and Tahiti. That his mission to these places was a supremely artistic one is proved by the manner in which

he spent his time there, while the fact that it was discontent with, and scorn of, European conditions and people that drove him in search of better climes and nobler types, is proved by his behaviour both in Tahiti and in the Marquesas Islands.

Although we do not forget that Gauguin had been a sailor, if it were merely a sort of restless "Wanderlust" à l'Americaine that sent him to Oceania, why did he do all in his power to fight Occidental civilization in these parts? If in his heart of hearts he had not been utterly without hope and without trust where Europe was concerned, why did he start a paper at Papeete, in which he sought to convert the colonists and educated natives to his hostile attitude towards the European? Why, too, did he jeopardize his peace of mind as well as his safety, by taking the side of the Marquesans when they implored him to defend them against their white oppressors? For we know that he was not only arrested but heavily fined for this action.

It is obvious that Gauguin was much more than a mere itinerant painter out for "new material." He was above the modern senseless mania for rugged landscape as an end in itself, or for "tropical sunsets" and "dramatic dawns," in the South Pacific. And when we read Van Gogh's words on the natives of the Marquesas (page 42) we can no longer doubt, not only that Gauguin influenced him, but also that this influence was deep and lasting.

Personally, I feel not the slightest hesitation in accepting Gauguin's own words, quoted above, concerning his relationship to Van Gogh, and though I ascribe the latter's final positive and human attitude in art very largely to the soundness of his own instincts, I cannot help feeling also that the spirit of that half-Breton and half-Peruvian magician was largely instrumental in determining the less-travelled and less-profound Dutchman to assume his final phase in art.

If Van Gogh had had more opportunities for figure painting, and if his hand and eye had grown more cunning in the art of depicting his fellows, I am of opinion that he might have surpassed even his master and inspirer. For that isolated event, that "sport," the portrait of the "Fair Girl," which was, alas, the one swallow that did not make a summer, remains stamped upon my memory as a solid guarantee of his exceptional potentialities. Unfortunately, however, he came to figure-painting all too late, and his opportunities for practising his hand were rare and more or less isolated. In these letters he says: "I suffer very much from having absolutely no models" (page 116); while in a letter to his brother, not included in this volume, he writes rather amusingly as follows: "Si on peignait lisse comme du Bouguereau les gens n'auraient pas honte de se laisser peindre. Je crois que cette idée que c'était 'mal fait,' que c'était que

des tableaux pleins de peinture que je faisais, m'a fait perdre des modèles. Les bonnes putains ont peur de se compromettre et qu'on se moque de leur portrait."[17]

There is now only one more point to be discussed, and I shall draw this somewhat lengthy essay to a close. I feel, however, that it would be incomplete without some reference to Van Gogh's personal appearance. Whatever democratic and over-Christianized people may say to the contrary, a man can be neither ugly nor good-looking with impunity. Looks are everything. "Appearances are deceptive," is a proverb fit only for those who are either too corrupt or too blind to use with understanding and profit the precious sense that lies beneath their superciliary arches. Van Gogh's personal appearance is, therefore, in my opinion a most important matter, for I absolutely refuse to believe that beauty can proceed from ugliness or *vice versâ*. I leave such beliefs to those who have ugly friends or relatives to comfort or console. Then the doctrine that a fine mind or a fine soul can sanctify or transfigure any body—however foul, ugly, or botched—is, I admit, an essential and very valuable sophism.

Now, I am in the unfortunate position of one who has only portraits to judge from. But although I have seen only portraits, perhaps the number of these is sufficiently great to justify my forming an opinion. In all I have seen seven portraits of Van Gogh painted by himself, and one painted by Gauguin. The best and by far the most beautiful of all these is Van Gogh's portrait of himself now in the possession of Leonhard Tietz of Cologne. If we take this as a trustworthy record of Van Gogh's features, he certainly must have been what I would call a good-looking man. His brow was thoughtful, his eyes were deep, large, and intelligent, his nose was not too prominent and it was shapely, while his lips, both full and red, gave his face that air of positiveness towards life and humanity, which we find both in ancient Egyptian and present Chinese countenances. The only faults I find with his features and general colouring are, first, that they are inclined to be a little too northern and too Teutonic in type—a fact which suggests that his positive attitude to life was more intellectual than physiological—and, secondly, that his furtive eye suggests more timidity than mastery. This portrait is, however, a remarkable piece of work, and taking all its other qualities into consideration, I see no reason to doubt precisely the accuracy of the likeness. A genial work of this sort is not genial only in particulars.

If, however, we are to judge from the other portraits, especially from the one in the possession of H. Tutein Nolthenius (of Delft), then we must certainly agree with Meier Graefe, that Van Gogh was "by no means engaging in appearance."[18] I mean by the expression "unengaging" that a face is negative, chaotic, misanthropic, resentful. And in two or three of the portraits by himself, Van Gogh certainly does give the impression of being

all these things. I should only like to remind the reader that in each of the "ugly" portraits, the technique and general treatment is so inferior to the work in the picture belonging to Tietz of Cologne, that one is justified in suspecting that the likeness has also suffered from inadequate expression.

If we now turn to Gauguin's portrait of his friend, in the possession of Frau Gosschalk-Bonger, we do indeed find an interesting, if not a good-looking face, though the northern and barbarian features are perhaps a little marked. The question is, was Gauguin able to seize a likeness? I have every reason to believe that he could, and I am even prepared to accept his uncorroborated testimony on this point.

Speaking of his first arrival in Arles, on a visit to his friend Van Gogh, he says:

"J'arrivai à Arles fin de nuit et j'attendais le petit jour dans un café de nuit. Le patron me regarde et s'écria: 'C'est vous le copain! Je vous reconnais!'

"Un portrait de moi que j'avais envoyé à Vincent est suffisant pour expliquer l'exclamation du patron. Lui faisant voir mon portrait, Vincent lui avait expliqué que c'était un copain qui devait venir prochainement."[19]

Thus I have attempted to make clear what I personally have learnt from Van Gogh, and what I believe to have been the course of his development and of his aspirations. In the process of my exposition I have spoken about stages and periods in his development and life, as if they were well-defined and plainly to be detected in his work, and I have even instanced particular pictures which I regard as more or less characteristic of his four manners or styles. I should like to warn the reader, however, that he must not expect to find these stages and periods as clearly defined in the mass of Van Gogh's life-work, as this essay may have led him to suppose he would. For the purpose of tracing this Dutch artist's career it was necessary to speak of these periods and stages as if they had been more or less definite. But, as a matter of fact, not only do they overlap each other to such an extent as completely to invalidate any claim to the effect that Van Gogh's progress was regular and gradual, but often his pictures as well as his thoughts of the first and second period, after the manner of harbingers, tell so plainly what will be the aim and the triumph of the next or even ultimate period, that it is impossible to fix or even to find exact boundaries.

All that there now remains for me to do is, in the first place, to offer an explanation as to the inordinate length of this introductory essay, by pointing to the fact that nothing of the kind has previously been done for

the English-reading public, and that I therefore felt my task of introducing Van Gogh might be done both conscientiously and exhaustively without my running the risk wearying the reader; and, secondly, to express the hope of that this introduction may prove as helpful to the student interested in Van Gogh's works, as I feel it would have been to me at the time when I first set out to study the life, the aims and the works of this remarkable and much misunderstood Dutch painter.

ANTHONY M. LUDOVICI.

PREFACE

VINCENT VAN GOGH was born in 1853, at Groot-Zundert, a village in the province of North Brabant in Holland, and was the son of a clergyman. Like his two uncles, he was destined to be an art dealer, and from the time when he finished his education, until his twenty-third year, he worked for the firm of Goupil at The Hague, in London, and in Paris. He left Paris to return to England, where for a short time he was engaged as a schoolmaster in the country. But this did not satisfy him either; and he now wished to study theology at Amsterdam. When, however, he discovered that these studies also failed to give him precisely what he was seeking he left for Belgium, where he went among the miners as an evangelist.

There among the coal-mines he began to draw. After going to Brussels he returned in 1881 to his home, where he began to pursue independent studies until he moved to The Hague, and for the first time entered into relations with other painters. In 1883 he went into the province of Drenthe, and very shortly afterwards back again to Brabant, where he worked strenuously until 1885. The things he drew and painted there, in Zundert, were already stamped with an exceedingly strong personal character, though they are very different from the works belonging to his later French period.

In 1885 he attended the Academy of Antwerp for a few months, and in the spring of 1886 we find him in Paris, where, thanks to his brother, Theodore van Gogh, an art dealer with exceptionally good taste, he became acquainted with the art of the Impressionist school, and entered into personal relations with one or two of its exponents.

Very soon after this he travelled southward, and worked first at Arles and later at St. Remy. In the works of this period he approached much more closely to the modern French school than to the art of his native land.

The remainder of his life was spent in a Hospital for Diseases of the Nerves at Auvers-sur-Oise, where he died in 1890.

His art was appreciated during his life only by a very few and it is but within recent years that it has found admirers who in many cases have been most ardently enthusiastic.

Of the following letters, some were addressed to his brother and the remainder to his friend E. Bernard.

LETTERS TO HIS BROTHER

DEAR BROTHER,

You must not take it amiss if I write to you again so soon. I do so only in order to tell you how extraordinarily happy painting makes me feel.

Last Sunday I began something which I had had in mind for many a day:

It is the view of a flat green meadow, dotted with haycocks. A cinder path running alongside of a ditch crosses it diagonally. And on the horizon, in the middle of the picture, there stands the sun. The whole thing is a blend of colour and tone—a vibration of the whole scale of colours in the air. First of all there is a mauve tinted mist through which the sun peers, half concealed by a dark violet bank of clouds with a thin brilliant red lining. The sun contains some vermilion, and above it there is a strip of yellow which shades into green and, higher up, into a bluish tint that becomes the most delicate azure. Here and there I have put in a light purple or gray cloud gilded with the sun's livery.

The ground is a strong carpet-like texture of green, gray and brown, full of light and shade and life. The water in the ditch sparkles on the clay soil. It is in the style of one of Emile Breton's paintings.

I have also painted a large stretch of dunes. I put the colour on thick and treated it broadly.

I feel quite certain that, on looking at these two pictures, no one will ever believe that they are the first studies I have ever painted.

Truth to tell, I am surprised myself. I thought my first things would be worthless; but even at the risk of singing my own praises, I must say that they really are not at all bad. And that is what surprises me so much.

I believe the reason of it is that before I began to paint, I made such a long and careful study of drawing and perspective that I can now sketch a thing as I see it.

Now, however, since I have bought my brushes and painting materials, I have slaved so hard that I am dead tired—seven colour studies straight off!... I literally cannot stand, and yet I can neither forsake my work nor take a rest.

But what I also wanted to say is that when I am painting things present themselves to me in colour, which formerly I never used to see—things full of breadth and vigour.

All this looks as if I were already satisfied with my own work; but I feel just the contrary. Up to the present, however, I have progressed to the extent that when anything in Nature happens to strike me, I have more means at my command than I had formerly for expressing that thing with force.

Nor do I think that it would matter much if my health played me a nasty trick. As far as I am aware, they are not the worst painters who from time to time feel as if they can do no work for a week or two. For their compulsory idleness is probably due chiefly to the fact that they are the very ones who, as Millet says, "*y mettent leur peau.*" That does not matter, and no one should pay any heed to such lapses. For a while you are utterly exhausted, but you soon get right again; and then at least you are the richer for having garnered a number of studies, as the peasant garners a load of hay. But for the moment I am not yet contemplating a rest.

I know it is late, but I really must write you a few lines. You are not here and I miss you, though I feel as if we were not so very far from each other.

I have just decided to pay no further heed to my indisposition, or rather to all that is left of it. Enough time has been lost and I must not neglect my work. Therefore, whether I am well or not, I shall again draw regularly from morn till night. I do not want anybody to be able again to say of my work: "Ah, those are all old drawings!"

...In my opinion my hands have grown too delicate; but what can I do? I shall go out again, even if it cost me a good deal; for my chief concern is that I should not neglect my work any longer. Art is jealous; she will not allow illness to take precedence of her. And I give in to her.

...Men like myself really have no right to be ill. But you must understand what my attitude is to Art. In order to attain to real Art one must work both hard and long. The thing I have set my mind upon as the goal of all my efforts is devilish difficult, and yet I do not think that I am aiming too high. I will make drawings that will amaze some people.

In short I will bring it to such a pitch, that they will say of my work: "The man feels deeply and he is subtle withal"; in spite of my so-called coarseness, do you understand? maybe precisely on that account. At present

it sounds presumptuous to speak in this way; but it is for this very reason that I wish to put vigour into my work.

For what am I in the eyes of most people? A nonentity, or an oddity, or a disagreeable man, some one who neither has nor ever will have any place in society—in short something less than the least.

Well, granting that this is so, I should like to show by my work what the heart of such a nonentity, of such an insignificant man, conceals.

This is my ambition which for all that is the outcome more of love than of resentment, more of a feeling of peaceful serenity than of passion. And even though I often have to contend with all kinds of difficulties, yet I feel within me a calm, pure harmony and music.

Art requires resolute and unremitting industry, as well as incessant observation. By resolute industry I mean, in the first place, constant industry, as also the power of maintaining one's own point of view against the assertions of others.

Latterly I have had precious little intercourse with other painters and have not felt any the worse for it. One should not pay so much heed to the teaching of painters as to the teaching of Nature. I can understand better now than I did six months ago that Mauve should have been able to say: "Do not speak to me about Dupré; speak to me rather about the edge of your ditch, or things of that sort." It certainly sounds strange, but it is absolutely right. A feeling for things in themselves, for reality, is much more important than a sense of the pictorial. It is more fruitful and animating.

In regard to the difference between ancient and modern Art, I should like to say that I think modern painters are perhaps greater thinkers.

Rembrandt and Ruysdael seem to us great and sublime, just as they did to their contemporaries; but there is something more personal and more intimate in the modern painter, which makes a stronger appeal to us.

I made another study of the little child's cradle to-day, and have put in colour here and there. I trust I may yet be able to draw the little cradle a hundred times over resolutely.

In order to make studies out of doors, and to paint a small sketch, a very strongly developed feeling for form is a pre-requisite. And this feeling is equally necessary for the subsequent further elaboration of one's work.

In my opinion, however, this is not acquired automatically, but chiefly through observation, and furthermore through strenuously working and

seeking. A study of anatomy and perspective is undoubtedly necessary as well.

At my side there hangs a landscape study by Roeloffs (a pen-and-ink drawing); but I cannot describe the full expressiveness of its simple silhouette. For everything depends upon that.

Another and even more striking example is the large wood-engraving of Millet's *Bergère*, which I saw at your place last year, and of which I still have the most vivid recollection. While there are also Ostade's and Bauern-Breughel's small pen-and-ink drawings, for instance.

I have once more tackled the old pollard-willow, and I believe that it is the best of my water-colours. It is a dark landscape. My desire was to paint it in such a way that the spectator must read and sympathize with the thoughts of the signal man with his red flag, who seems to say, "Oh, what a gloomy day it is!"

I am deriving great pleasure from my work just now, although from time to time I feel the after-effects of my illness somewhat severely. As to the market value of my pictures, I should be very much surprised if, in time, they did not sell as well as other people's. Whether this happens directly or later on does not matter to me. But to work faithfully and earnestly from Nature is, to my mind, a safe and sure road which must lead to one's goal.

Sooner or later a love of Nature always meets with response from people interested in Art. Therefore it is the painter's duty to become absorbed in Nature, to exercise all his intelligence, and put all his feeling into his work so that it may be comprehensible to others. But to work with a view to sell is, in my opinion, not the proper way, neither should we consider the taste of the art-lover—the great painters never did so. For the sympathy which sooner or later rewarded their efforts, they had to thank only their own honesty. That is all I know about it, and I do not believe that I require to know any more. To work in order to find people who will appreciate one, and in order to kindle love in them, is a very different thing, and naturally a very right one too. But nothing of the nature of a speculation should be attempted; for this might turn out wrong, and then much time would have been spent in vain.

Among the water-colours I have just painted, you will find many things that ought to be eliminated—but that will come in time. But please understand me, I have not the remotest idea of abiding by a system, or anything of the sort.

Now farewell! And believe me that I often have a hearty laugh at the thought that people should reproach me with certain absurdities and

iniquities which have never so much as entered my head; for what am I but a friend of Nature, of study, of work, and above all of man?

DEAR THEO,

A day or two ago I paid another visit to Scheveningen, and in the evening had the pleasure of seeing a fishing smack enter the harbour. Near the monument there is a wooden hut on which stood a man who was waiting. As soon as the smack sailed into view, this man appeared with a large blue flag, and was followed by a number of little children who did not reach to his knees. Apparently it was a great joy for them to stand near the man with the flag. They seemed to think that their presence contributed largely to the successful entry of the fishing smack. A few minutes after the man had waved his flag, another man came along on an old horse, who was to heave in the cable. Men and women, and mothers with their children, now joined the little group, in order to welcome the vessel.

As soon as the boat had drawn sufficiently near, the man on horseback entered the water and soon returned with the anchor.

Then the boatmen were carried ashore on the shoulders of men wearing jack-boots, and happy cries of welcome greeted each new arrival.

When they were all assembled on land, the whole party walked to their homes like a flock of sheep or a caravan, led by the man on the camel—I mean on the horse—who soared above the little crowd like a huge shadow.

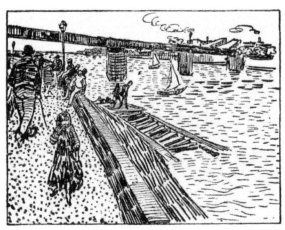

I naturally made the most frantic efforts to sketch the various incidents. I also painted a little, especially the small group, of which I give you a thumb-nail sketch herewith.... From the accompanying drawing you

will be able to tell what I am endeavouring to do—that is, to represent groups of people pursuing this or that occupation. But how hard it is to make things look busy and alive, and to make the figures take their place and yet stand out from one another! It is a difficult thing to render the swaying of the crowd and a group of figures of which some are head and shoulders above the rest, though they all form a whole when seen from above. Whereas the legs of the nearest figures stand out distinctly in the foreground, the coats and trousers behind and above form a most bewildering muddle, in which, however, there is plenty of drawing. And then right and left, according to the point of vision, there is the further expansion or foreshortening of the sides. Every kind of scene and figure suggests a good composition to me—a market, the arrival of a boat, a group of men outside a soup-kitchen, the crowds wandering and gossiping in the streets—on the same principle as a flock of sheep—and it is all a matter of light and shade and perspective.

It really is strange that you and I should always have the same thoughts. Last night, for instance, I returned from the wood with a study—for this week I have been particularly busy investigating the question of increasing the intensity of colour—and I should have been glad to discuss this matter with you in connection with the study I had made, when lo and behold! in your letter this morning, you just happen to mention the fact that you were struck with the strong and yet harmonious colouring in Montmartre.

...Yesterday evening I was busy painting the gently rising ground in the wood, which is all strewn with dry withered beech leaves. It varied in colour from a light to a dark red-brown, and the cast shadows of the trees fell across it in faint or strongly marked stripes. The difficulty was—and I found it very trying—to succeed in getting the depth of the colour and the enormous strength and solidity of the ground—and I noticed while I worked how much light there was even in the dark shadows! The thing was to render the effect of light and also the glow, and not to lose the depth of rich colour. For one cannot imagine a more magnificent carpet than that deep red-brown ground, bathed in the glow of the autumn evening sunlight, softened by its passage through the trees.

Beech trees grow here, the trunks of which look bright green in the clear light and a warm black-green in the shade. Behind the trunks, above the red-brown ground one could see the delicate blue and warm gray of the sky—it was scarcely blue—and in front of it a diaphanous haze of green, and a maze of trees with golden leaves. The forms of a few peasants gathering wood crept about like dark mysterious shadows, while the white

bonnet of a woman bending to gather a few dried twigs suddenly stood out from the deep red-brown of the earth. A coat caught the light, a shadow was cast, and the dark silhouette of a man appeared high on the edge of the wood. The white bonnet, the shoulders, and bust of a woman stood out against the sky. The figures were large and full of poetry and, in the twilight of the deep shadows, seemed like gigantic terracottas fashioned in a studio. That is how I describe Nature to you. How far I have rendered the effect in my sketch, I do not know. I can only say that I was struck by the harmony of green, red, black, yellow, blue, and gray. It was quite in the style of de Groux; the effect was like that in the sketch of the "Départ du Conscrit."

To paint it was a herculean task. On the ground alone I used one and a half large tubes of white; and yet it is still very dark. I also used red, yellow, brown, yellow-ochre, black, raw sienna and bistre—and the result is a red-brown, which varies from a deep wine-red to a delicate pale pink. It is very difficult to succeed in getting the colour of the moss and the effect of the small border of fresh grass which shone so brightly in the sunlight. Believe me, this is a sketch which, if I may say so, people will think something of, for it makes a decided appeal.

While working upon it, I said to myself: "Do not put down your palette before your picture seems to partake of the mood of an autumn evening, before it is instinct with mystery and with a certain deep earnestness."

But, in order not to lose the effect, I have to paint quickly. The figures are painted in rapidly with a few vigorous and firm brush-strokes. I was struck with the sturdy manner in which the tree-trunks strike their roots into the ground. I began painting them with the brush and I did not succeed in rendering the character of the ground which was already laid on with thick colour,—a stroke of the brush vanished to nothing upon it. That is why I pressed the roots and trunks out of the tubes direct, and then modelled them a little with the brush. And now they do indeed stand in the soil, and grow out of it, and strike firm roots into it.

In a sense I am glad that I never learnt to paint. If I had I should perhaps have learnt to overlook such effects. Now I say, "No!—this and only this must I have, and if it is impossible, well then, it is impossible, that's all. I will have a shot at it although I do not know the right way to do it."

I really do not know how I paint. Armed with a white panel I take up a position in front of the spot that interests me, contemplate what lies before me, and say to myself "That white panel must be turned into something." Dissatisfied with my work I return home, put my panel out of sight, and after taking a little rest, go back to my work, almost with qualms

to see what it looks like. But even then I am not yet satisfied, for glorious Nature is still too vividly stamped upon my mind. Nevertheless I find in my work a certain reverberation of that which fascinated me. I know that Nature told me something, that she spoke to me, and that I took down her message in shorthand. Perhaps my stenographic transcript contains words that are undecipherable; belike there are faults and omissions in it too; still it may possess something that the wood, the beach, or the figures said. And this is never in a tame or conventional language that did not spring from Nature herself.

As you perceive, I am entering heart and soul into painting, and I am deeply engaged in the study of colour. Hitherto I had held myself aloof from it, and I am not sorry that I did. Had I not drawn, I could have no feeling for a figure that looks like an unfinished terracotta, nor could I have undertaken to paint such a thing. Now, however, I feel that I am in mid-sea—now I must set about painting with all the strength at my command.

...I am certain that I have the feeling for colour, that I shall acquire it more and more, and that painting is in my very marrow.

It is not the extravagant use of paint that makes the painter. But, in order to lend vigour to a piece of ground and to make the air clear, one should not be particular about a tube or two. Often the very spirit of the thing one is painting leads one to paint thinly; at other times the subject, the very nature of the things themselves, compels one to lay the colour on thickly.

At Mauve's studio—who compared with J. Maris, and to an even greater extent with Millet or Jules Dupré, uses paint very moderately—there are as many old cigar boxes filled with empty tubes as there are empty bottles in the corner of a room after an evening's bout (as Zola describes such a function, for instance).

You inquire after my health. How is yours? I should say that my treatment ought to suit you—*i.e.*, to be out in the air and to paint. I am quite well. I have to pay for a little fatigue, but still on the whole I feel if anything rather better. I believe it is a good thing for me to lead such a temperate life. But that which does me the most good of all is painting.

DEAR THEO,

I wish that the three pictures, about which I wrote to you, had already been despatched. I fear that if I keep them here much longer, I may paint them over again, and I believe it would be better for you to get them just as they are.

Don't you think that, after all, it is better for us two to work diligently, even though we have to put up with a good deal in so doing, than to sit down and philosophize, especially at a time like the present? I do not know the future, Theo; but I know the eternal law of change. Think how different things were ten years ago—the circumstances of everyday life, the attitude of men's minds, in fact everything; and ten years hence many other things will have changed also. But fancy having created something lasting! And one does not repent so soon for having created something. The busier I am the better; I prefer a piece of work that is a failure to inactivity.

We shall not have to wait so very long before what we are now producing will have become important. You yourself can see well enough— and it is one of the signs of the times with which I am most pleased—that there is a growing tendency for people to give one-man shows, or exhibitions of the work of a few men who belong to the same school. In my opinion this is a development in the art-dealing world which will have a far greater future than other enterprises. What a good thing it is that people are beginning to understand that the effect is bad when a Bouguereau is placed beside a Jacques, or a figure by Beyle or Lhermitte is hung close to a Schelfhout or a Koekkoek.

If I kept my work by me for long, I feel sure I should paint many of the pieces over again. But owing to the fact that I send them either to you or to Pottier the instant they are free from my brush, a number of them will probably not be worth much,—though by this means many studies will be preserved which otherwise would not have been improved by repeated retouching.

Peasant life provides such abundant material that *"travailler comme plusieurs nègres,"* as Millet says, is the only possible way of accomplishing anything.

People may laugh at Courbet's having said: "Paint angels? But who on earth has ever seen an angel?" Yet on the same principle I should like to say of Benjamin Constant's "La Justice au Harem," for instance, who has ever seen a court of justice in a harem? And the same thing applies to so many other Moorish and Spanish pictures,—"The Reception at the Cardinal's, etc." And then there are all the historical pictures which are always as long as they are broad—what is the good of them all? And what do their painters mean by them? They will all lose their freshness and look like leather in the space of a few years, and will grow ever more and more tedious.

...When, nowadays, connoisseurs stand before a picture like the one by Benjamin Constant, or before a reception given by a Cardinal, painted by some Spaniard or other, they have acquired the habit of gravely muttering something about "clever technique." If, however, the same men were to stand before a scene from peasant life—a drawing by Raffaëlli—they would criticize the technique with the same gravity.

...I do not know what you think, but as far as I am concerned, the more I study peasant life, the more it absorbs me, and the less I care for the kind of thing painted by Cabanel (with whom I also reckon Jacques and the modern Benjamin Constant) and for the highly respected and unspeakably dry technique of the Italians and the Spaniards. "Mere illustrators!" I am always reminded of these words of Jacques. Still, I am not prejudiced; I can appreciate Raffaëlli, who is something very different from a painter of peasants; I can also appreciate Alfred Stevens and Tissot. And, to speak of something which has nothing in common with peasant life, I can appreciate a beautiful portrait. Zola, who, by-the-bye, in my opinion, is stupendously at sea in regard to painting, says something very fine about art in general in "Mes Haines": "*Dans l'œuvre d'art je cherche, j'aime l'homme, l'artiste.*" Now I think that is absolutely right. Just tell me what sort of a man, what sort of an observer, thinker and character, is at the back of these pictures, the technique of which is held in such high esteem? Very often nobody. But a Raffaëlli *is* somebody, a Lhermitte *is* somebody. And in the presence of a number of pictures by almost unknown painters, one is conscious of the great energy, feeling, passion and love with which they are painted.

When one thinks how far one has to go and how much one must slave in order to paint an ordinary peasant and his cot, I almost believe that this journey is longer and more fatiguing than that which many painters undertake in order to get their outlandish subjects—"La Justice au Harem" or "The Reception at the Cardinal's," for instance—and to paint their frequently far-fetched and eccentric stories. Fancy living the daily life of the peasants in their cots and in the country, enduring the heat of summer and the snow and frost of winter—not indoors but out in the fields, and not for a leisurely walk—no! but for daily work like that of the peasants themselves.

Apparently nothing is more simple than to paint a rag-picker, a beggar or any other kind of workman; but there are no subjects which are so difficult to paint as these everyday figures. I do not think there is a single academy where one can learn to draw or paint a man digging or sowing seed, a woman hanging a pot over the fire or doing needlework. But in every city, however insignificant it may be, there is an academy with a whole selection of models for historical, Arabian, and in short, all kinds of figures, which do not exist in the real everyday world of Europe.

All academic figures are grouped together in the same manner, and we will readily acknowledge that *on ne peut mieux*. Quite impeccable—faultless! But you are already aware of what I mean: they teach one absolutely nothing new.

Not so the figures painted by a Millet, by a Lhermitte, by a Régamey, or a Daumier. All their figures are also well grouped, but in a very different way from that taught by the academy. My belief is that an academical figure, however accurate it may be, is at present quite superfluous—even though it be painted by Ingres himself (I would in any case except his "Source," which was indeed something new, and will remain so)—if it lack that essential quality of modernity, that intimate feeling, that quality of having been created to meet a need.

In what circumstances, then, do figures cease from being superfluous, however faulty, and grossly so, they may be? When the man who digs is really digging, when the peasant is a peasant, and the peasant woman a peasant woman. Is that something new? Yes, even the figures of Ostade and Terborch have not the same effect as those in modern pictures.

I should like to say a good deal more about these things, but in any case I feel I must tell you how many of the studies that I have started I should like to improve, and how much higher than my own work I consider that of a few other artists. Now tell me, do you know of a single picture of a man digging or sowing seed in the old Dutch School? Did they ever attempt to paint a workman? Did Velasquez attempt it in his "Water Carrier" or in his types of the people? No!

The figures of the old masters do not "work." At present I am very busy with the figure of a woman whom I saw pulling mangels out of the snow. Now, this is what Millet and Lhermitte did, and this is practically what the peasant painters of this century and Israels did. They thought it was more beautiful than anything else. But even in this century, among the host of painters who pay particular attention to the figure, *i.e.*, for the sake of form and of the model, there are precious few who cannot conceive their figures otherwise than at work, and who feel the need of representing activity as an end in itself. The ancients did not feel this need, nor did the old Dutch masters, who concerned themselves extensively with conventional forms of activity.

Thus the picture or the drawing ought to be not only a study of a figure for the sake of the figure, and the incomparably harmonious form of the human body—but at the same time "a gathering of mangels in the snow"! Have I made myself clear? I hope so, for, as I once said to Seurat, a

nude by Cabanel, a lady by Jacques, and a peasant woman, not by Bastien-Lepage himself, but by a Parisian painter who has learnt drawing at the academy, will always have her limbs and body expressed in the same way—often quite charmingly, and, as far as proportions and anatomy are concerned, quite correctly. When, however, Israels, Daumier or Lhermitte, for instance, draw a figure, one is much more conscious of the form of the body, although—and that is why I include Daumier in the number—the proportions will tend to be almost arbitrary. The anatomy and structure of the body will not always seem quite correct in the eyes of the academician. But it will have life, particularly if it come from the brush of Delacroix.

I have not expressed myself quite satisfactorily yet: tell Seurat that I should despair if my figures were correct; tell him that if you take a photograph of a man digging, in my opinion, he is sure to look as if he were not digging; tell him that I think Michelangelo's figures magnificent, even though the legs are certainly too long and the hips and the pelvis bones a little too broad; tell him that in my opinion Millet and Lhermitte are the true painters of the day, because they do not paint things as they are, dryly analysing them and observing them objectively, but render them as they feel them; tell him it is my most fervent desire to know how one can achieve such deviations from reality, such inaccuracies and such transfigurations, that come about by chance. Well yes, if you like, they are lies; but they are more valuable than the real values.

Men who move in artistic and literary circles, like Raffaëlli in Paris, ultimately think very differently about such things from what I do, who live in the country. I mean that they are in need of a word which is expressive of their ideas. Raffaëlli proposes the word "character" as the feature of the figures of the future. I think I agree with the intention here, but I question the correctness of the word, just as I question the correctness of other words, and just as I question the accuracy and appropriateness of my own expressions. Instead of saying, there must be character in a man who is digging, I paraphrase the thing and say, the peasant must be a peasant, the digging man must dig, and in this way the picture acquires a quality which is essentially modern. But I am well aware that conclusions may be drawn from these words which I do not in the least intend.

You see, to render "the peasant form at work" is, I repeat, the peculiar feature, the very heart of modern art, and that is something which was done neither by the Renaissance painters, nor the old Dutch masters, nor by the Greeks.

At the start the figure of the peasant and of the workman constituted a "genre" picture; but at the present moment, with Millet, the immortal

master in the van, this theme has become the very soul of modern art and will remain so.

People like Daumier ought to be esteemed very highly, for they are pioneers.... The more artists would paint peasants and workmen the happier I should be. And as for myself, I know nothing that I would do more gladly.

This is a long letter, and I do not know whether I have expressed my meaning clearly enough. Maybe I shall write just a few lines to Seurat. If I do so, I shall send them to you to read through, as I should like them to contain a clear statement of the importance I attach to figure painting.

...What impressed me most on looking back at the old Dutch pictures, was the fact that in the majority of cases they were painted rapidly, and that great masters like Hals, Rembrandt, Ruysdael, and many others, painted as much as possible *du premier coup* and avoided overmuch retouching.

What I admired above all were hands by Rembrandt and Hals, hands full of life, though unfinished; for instance, some of the hands in the "Syndics of the Cloth Hall," and in the "Jewish Bride." And I felt much the same in regard to some heads, eyes, noses and mouths, which seemed to be laid on with one single stroke of the brush, and without any sign of retouching. Bracquemond has made such good engravings of them that one can appreciate the painter's technique in the print.

But, Theo, how necessary it is, especially at the present day, to study the old Dutch pictures, and such of the French as those by Corot, Millet, etc. At a pinch one can well dispense with the others, for they often lead one further astray than one imagines. The thing is to keep at it, and to paint everything as far as possible at one go! What a real joy it is to see a Franz Hals! How different these pictures are from those in which everything seems to be painted in the same smooth way, like lacquer.

On the very same day on which I saw the old Dutch masters, Brouwer, Ostade, and above all Terborch, I just chanced to see a Meissonier—the one of the Fodor Museum.[20] Now Meissonier worked in exactly the same way as they did; his pictures are very deeply thought out and deliberated, but painted at one stroke, and probably with every touch quite right from the start.

I believe it is better to scrape an unsuccessful portion of one's picture completely away and to begin again, than to keep on trying to improve it.

I saw a sketch by Rubens and another by Diaz almost at the same time. They were certainly not alike, but the creed of the artists who painted them was the same—the conviction that colour expresses form when it is

in the right place with the right associations. Diaz in particular is a painter to the backbone, and is conscientious to the finger-tips.

I must refer once more to certain modern pictures, which are becoming ever more and more plentiful. About fifteen years ago people began to speak about "luminosity" and "light." Even if this was right in the first place—and one cannot deny that the system produced very masterful works—it is now beginning to degenerate ever more and more throughout the whole of the art-world into an excessive production of pictures which have the same lighting on all four sides, the same general atmosphere as I believe they call it, and the same local colour. Is that good??? I do not think so.

Does the Ruysdael of van der Hoop (the one with the Mill) give one the impression of open air? Is there any atmosphere in it—any distance? The earth and the air constitute a whole and belong to each other.

Van Goyen is the Dutch Corot. I stood for a long while before the monumental picture in the Dupper collection.

As for Franz Hals's yellow, you can call it what you like, *citron amorti* or *jaune chamois*, but what have you gained? In the picture it appears to be quite light, but just you hold something white against it.

The great doctrine bequeathed to us by the Dutch masters is, I think, as follows: Line and colour should be seen as one, a standpoint which Bracquemond also holds. But very few observe this principle, they draw with everything, save with good colour.

I have no desire to make many acquaintances among painters.

But to refer to technique once more. There is very much more sound and skilful stuff in Israel's technique—above all in the very old picture "The' Zandvoort Fisherman," for instance, in which there is such splendid chiaroscuro, than in the technique of those who, owing to their steely cold colour, are uniformly smooth, flat, and sober throughout.

"The Zandvoort Fisherman" may safely be hung beside an old Delacroix, such as "La Barque de Dante," as they are both members of the same family. I believe in these pictures, but grow ever more and more hostile to those which are uniformly light all over.

It irritates me to hear people say that I have no "technique." It is just possible that there is no trace of it, because I hold myself aloof from all painters. I am, however, quite right in regarding many painters as weak precisely in their technique—more particularly those who talk most

nonsense about it. This I have already written to you. But if ever I should happen to exhibit my work with either the one or the other in Holland, I know beforehand with whom I shall have to deal, and with what order of technicians. Meanwhile I much prefer to remain faithful to the old Dutchmen, the pictures of Israels and his school. This the more modern painters do not do; on the contrary, they are diametrically opposed to Israels.

That which they call "luminous" is, in many cases, nothing else than the detestable studio lighting of a cheerless town studio. They do not seem to see either the dawn or the setting sun; all they appear to know are the hours between 11 a.m. to 3 p.m.—quite pleasant hours forsooth, but often quite uninteresting ones too!

This winter I wish to investigate many things which have struck me in regard to the treatment in old pictures. I have seen a good deal that I lack. But above all that which is called *enlever*,[21] and which the old Dutch masters understood so perfectly.

No one nowadays will have anything to do with *enlever* in a few strokes of the brush. But how conclusively its results prove the correctness of it! How thoroughly and with what mastery many French painters and Israels understood this! I thought a good deal about Delacroix in the Museum. Why? Because, while contemplating Hals, Rembrandt, Ruysdael, and others, I constantly thought of the saying, that when Delacroix paints, it is exactly like a lion devouring a piece of flesh. How true that is! And, Theo, when I think of what one might call "the technique crew" how tedious they all are! Rest assured, however, that if ever I have any dealings with the gentlemen, I shall behave more or less like a simpleton, but *à la Vireloque*—with a *coup de dent* to follow.

For is it not exasperating to see the same dodges everywhere (or what we call dodges)—everywhere the same tedious gray-white light, in the place of light and chiaroscuro, colour, local colour instead of shades of colour....

Colour as colour means something; this should not be ignored, but rather turned to account. That which has a beautiful effect, a really beautiful effect, is also right. When Veronese painted the portraits of his *beau monde* in the "Marriage' at Cana," he used all the wealth of his palette in deep violets and gorgeous golden tones for the purpose, while he also introduced a faint azure blue and a pearly white which do not spring into the foreground. He throws it back, and it looks well in the neighbourhood of the sky and of the marble palaces, which strangely complete the figures; it changes quite of its own accord. The background is so beautiful that it seems to have come into being quite naturally and spontaneously out of the colour scheme.

Am I wrong? Is it not painted differently from the way an artist would have painted it who had conceived the figures and the palace as a simultaneous whole?

All the architecture and the sky are conventional and subordinate to the figures, they are simply calculated to throw the latter into relief.

This is really painting, and it yields a more beautiful effect than a mere transcript of things does. The point is to think about a thing, to consider its surroundings, and to let it grow out of the latter.

I do not wish to argue studying from Nature or the struggling with reality, out of existence; for years I myself worked in this way with almost fruitless and, in any case, wretched results. I should not like to have avoided this error however.

In any case I am quite convinced that it would have been foolery on my part to have continued to pursue these methods—although I am not by any means so sure that all my trouble has been in vain.

Doctors say, *"On commence par tuer, on finit par guérir."* One begins by plaguing one's self to no purpose in order to be true to nature, and one concludes by working quietly from one's palette alone, and then nature is the result. But these two methods cannot be pursued together. Diligent study, even if it seem to be fruitless, leads to familiarity with nature and to a thorough knowledge of things.

The greatest and most powerful imagination has also been able to produce things from reality, before which people have stood in dumb amazement.

...I will simply paint my bedroom. This time the colour shall do everything. By means of its simplicity it shall lend things a grand style, and shall suggest absolute peace and slumber to the spectator. In short, the mere sight of the picture should be restful to the spirit, or better still, to the imagination. The walls are pale violet, the floor is covered with red tiles, the wood of the bed and of the chairs is a warm yellow, the sheets and the pillow are a light yellow-green, the quilt is scarlet, the window green, the washstand is orange, the wash-basin is blue, and the doors are mauve. That is all—there is nothing more in the room, and the windows are closed. The very squareness of the furniture should intensify the impression of rest. As there is no white in the picture, the frame should be white. This work will compensate me for the compulsory rest to which I have been condemned. I shall work at it again all day long to-morrow; but you see how simple the

composition is. Shadows and cast shadows are suppressed, and the colour is rendered in dull and distinct tones like crape of many colours.

I have already taken many walks along the docks and dikes. The contrast is very strange, especially when one has just left the sand, the hearth, and the peace of a country farm behind one, and when one has lived for some time in quiet surroundings. It is an abyss of confusion.

Once the war-cry of the Goncourts was, "Japonaiserie' for ever." Now the docks are a splendid piece of Japonaiserie, both odd, peculiar, and terrific. At least they may be looked at in this way.

All the figures are constantly moving. They are seen in the very strangest environment—everything is monstrous, and the whole is full of the most varied and most interesting contrasts.

Through the window of a very stylish English restaurant one obtains a glimpse of the dirty mud of the harbour and of a ship of the horrid cargo type, from which foreign seamen are unloading hides and bullocks' horns. And close by, in front of the window, there stands a very dark, refined, and shy-looking girl. The room with the figure, all tone and light, the silvery sheen over the mud and the bullocks' horns—all these things produce the most striking contrasts.

Flemish seamen with extravagantly healthy faces, broad shoulders, powerfully and strongly built, and Antwerpian to the backbone, stand there eating mussels and drinking beer, and there is plenty of shouting and movement. On the other side, a short little form, dressed in black, with her hands on her hips, steals silently alongside of the gray wall.

Her little face, encircled in a halo of jet-black hair, is a note of tawny or orange yellow?—I don't know which. She has just looked up and cast a bashful glance with a pair of coal-black eyes. She is a Chinese girl, mysterious and as quiet as a mouse, small and beetle-like[22] in character, a contrast to the great Flemish consumers of mussels.

Thank Heaven! my digestion has so far recovered that I have been able to live on ships-biscuit, milk and eggs for three weeks. The beneficent heat is restoring my strength to me. It was wise of me to go South just now, when my bad state of health needed a cure. I am now as healthy as other people—a thing I have but seldom been able to say of myself—not since I was at Nuenen. It is very gratifying (among "other' people," I mean, the miners on strike, old Tanguy, old Millet, and the peasants).

The healthy man should be able to live on a piece of bread and keep at work all day. He should also be able to bear a pipe of tobacco and a good drink; for without these things nothing can be done. And withal he ought to have some feeling for the stars and the infinite heavens. Then it is a joy to live!

I should like to make copies of "The' Tarascon Diligence," "The Vineyard," "The' Harvest," and "The' Red Cabaret," especially of the night café, for its colouring is exceptionally characteristic. There is only one white figure in the middle which will have to be painted in afresh and improved in drawing, although it is good as far as its colour is concerned. The South really looks like this, I cannot help saying so. The whole scheme is a harmony in reddish green.

I do not need to go to the Museum and to see Titian and Velasquez. I have studied my trade in Nature's workshop, and now I know better than I did before I took my little journey, what is above all necessary if one wishes to paint the South. Heavens! what fools all these painters are! They say that Delacroix does not paint the Orient as it is. Only Parisians—Gérôme, etc.—can paint the Orient as it is—is that their claim? It really is a funny thing, this business of painting, out in the wind and the sun. And when the crowd looks over one's shoulder, one simply sets to like mad, as if the devil himself were at one's back, until the canvas is covered. It is precisely in this way that one discovers what everything depends upon. And this is the whole secret.

After a while one takes the study up again and attends a little more to the form. Then, at least, the thing looks less rough and more harmonious, and one also introduces something of one's own good cheer and laughter into it.

I am well aware of the fact that, to be healthy, one must resolutely wish to be so. Pain and even death must be faced, and all individual will and self-love must be renounced. That is nothing to me. I wish to paint and see men and things, the whole of pulsating life, even if it be only deceptive appearance. Aye! The true life is said to consist of something else: but I am not one of those who do not love life, and who are ready at all times to suffer and to die.

A man with my temperament can scarcely have success, lasting success. I shall probably never attain as much as I might and ought to attain.

I still believe that Gauguin and I will one day work together. I know that Gauguin is capable of greater things than he has given us already. Have you seen the portrait he painted of me while I was painting some sunflowers? My expression has certainly grown more cheerful since then, but at that time I looked just like that—absolutely exhausted and charged with electricity. If I had then had the strength to pursue my calling, I should have painted saintly figures of men and women from nature. They would have looked as if they belonged to another age. They would have been creatures of to-day and yet they would have borne some resemblance to the early Christians.

But that sort of thing is too wearing, it would have killed me. Nevertheless, I will not swear that later on, perhaps, I may not take up the struggle again. You are quite right, a thousand times right! One should not give a thought to such things. Painting studies is simply a taking of herbs to calm one, and when one is calm, well ... then one does what one is fitted for.

It really is a pity that there are so few pictures of poor people in Paris. I think that my peasant would look quite well by the side of your Lautrec. I even flatter myself that the Lautrec would look all the better for the strong contrast, while my picture would necessarily profit too from the peculiar juxtaposition; because sunniness and scorched tawny colouring, the hot sun and the open air, are thrown into stronger relief by the side of the powdered faces and the smart dresses. What a shame it is that the Parisians show so little taste for vigorous things, such as the Monticelli's, for instance.

Of course I am well aware of the fact that one must not lose courage because Utopias do not come true. All I know is this, that everything I learnt in Paris is going to the deuce, and I am returning to that which seemed to me right and proper in the country, before I had become acquainted with the impressionists. I should not be at all surprised if, within a short time, the impressionists found a great deal to criticize in my work, which is certainly much more under the suggestion of Delacroix' painting than of theirs. For, instead of reproducing exactly what I see before me, I treat the colouring in a perfectly arbitrary fashion. What I aim at above all is powerful expression. But let us drop theory, and allow me rather to make my meaning clear to you by means of an example.

Just suppose that I am to paint the portrait of an artist friend—an artist who dreams great dreams and who works as the nightingale sings, simply because it is his nature to do so.

Let us imagine him a fair man. All the love I feel for him I should like to reveal in my painting of the picture. To begin with, then, I paint him just as he is, as faithfully as possible—still this is only the beginning. The picture is by no means finished at this stage. Now I begin to apply the colour arbitrarily. I exaggerate the tone of his fair hair; I take orange, chrome, and dull lemon yellow. Behind his head, instead of the trivial wall of the room— I paint infinity. I make a simple background out of the richest of blues, as strong as my palette will allow. And thus, owing to this simple combination, the fair and luminous head has the mysterious effect, upon the rich blue background, of a star suspended in dark ether.

I proceed in much the same way with the portrait of the peasant. But one ought to picture this sort of fellow in the scorching noonday sun, in the midst of the harvest. Hence this flaming orange, like a red-hot iron; hence the luminous shadows like old gold. Ah, dear friend, the public will see only a caricature in this exaggeration. But what do we care? We have read "La' Terre" and "Germinal," and when we paint a peasant, we wish to show that this reading has become part of our flesh and blood.

I can only choose between being a good and a bad painter. I choose the former.

LETTERS TO E. BERNARD

I STILL believe that in studios one learns next to nothing about painting and certainly nothing about life, and that one should do all one can to learn to live and to paint without having recourse to those old fools and wiseacres.{A} [These numbers refer to the notes at the end of the book.— TR. (The numbers have been replaced with letters and curly brackets for clarification.[etext transcriber.])]

When our relations with a painter are so strained as to make us say: "If that fellow exhibits any of his pictures by the side of mine, I shall withdraw mine," and then proceed to abuse him, it seems to me that this is not the proper way to act; for, previous to arriving at such drastic conclusions one should make quite sure, and give the matter careful thought. After due reflection we are almost sure to find—particularly when we happen to be at loggerheads with the artist—that there is as much to criticize in our own work as in the other man's. He has as much right to exist as we have. When it is remembered that this man or that—be he a pointilliste or a member of another school—has often done good work, instead of disparaging him, we should speak of him with respect and sympathy, more particularly if he happen to be in disagreement with us. Otherwise we become too narrow-minded and are no better than those who can say no good of others and regard themselves alone as right. The observance of this principle ought even to be extended to the academicians. Take one of Fantin-Latour's pictures, for instance, or even the whole of his life-work! In any case he is not a revolutionary, and yet there is something restful and confident in his work, which elevates him to the rank of the most independent characters. For the good of all concerned, it is worth while abandoning the selfish principle: "Everyone' for himself."

MY DEAR BERNARD,

As I promised to write to you, I shall at once begin by saying that the country in these parts seems to me just as beautiful as Japan, as far as the clearness of the air and the cheerful colouring are concerned. In the landscape the water looks like sheets of fine emerald or of a rich blue of the shade with which we are familiar in crape prints.[23] Pale sunsets make the ground appear quite blue. Glorious golden suns! And I have not yet seen the country in the usual splendour of its summer garb. The costume of the women is pretty, and on Sundays especially very simple and happy combinations of colour may be seen on the boulevard. And there can be no

doubt that in summer things will be even gayer still. I only regret that living here is not so cheap as I had hoped it would be, and up to the present I have not succeeded in finding such inexpensive quarters as are to be found in Pont-Aven. At first I had to pay five francs a day, and now I pay four. If one could only speak the local dialect and eat *bouillabaisse* and *aioli*, one might certainly find an inexpensive pension in Arles.... Even if the Japanese do not make any headway in their own land, their art is certainly being continued in France. At the beginning of this letter I send you a small sketch of a study on which I am now engaged, and of which I should like to make something. Seamen with their sweethearts are going to the town, which, with its drawbridge, stands in wonderful outline against the yellow disc of the sun. I have also another study of the same drawbridge, with a group of washerwomen.

I should be very glad to have a word from you, just to know how you are and where you are going. With best wishes to you and our friends.

Your old friend
VINCENT.

I have just read a book about the Marquesas Islands. It was neither beautiful nor well-written, but it was heartrending inasmuch as it described the extermination of a whole tribe of aborigines—*cannibals*! They were cannibals in the sense that they ate one man, say once a month (what did that matter?)

The thoroughly Christian whites could think of no better way of putting an end to this barbarity, which on the whole was only mildly bloodthirsty, than by exterminating not only the tribe of aboriginal cannibals, but also the tribe with which they used to fight the battles calculated to provide both sides with the necessary prisoners of war to be eaten.

Then the two islands were annexed, and since then they have been unspeakably gloomy!

These tattooed races, niggers, Indians—everything, everything is either disappearing or degenerating. And the dreadful white man with his brandy, his purse, and his syphilis!—when will the world have had enough of him? The horrible white man, with his hypocrisy, his lust of gold, his sterility! And these poor savages were so full of gentleness and love!

There is real poetry in Gauguin's negresses. And everything that comes from his brush has something charming, something heartrending

and astounding about it. He is not yet understood, and he suffers greatly from not being able to sell his work like other true poets.

<div align="center">❖</div>

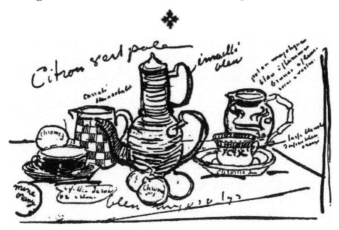

I have just taken a house. It is painted yellow outside and whitewashed within, and it stands right in the sun.

I have painted the following still-life: a blue-enamelled coffee pot, a royal blue cup and saucer, a milk jug decorated with pale-cobalt and white squares, a vase with a blue and orange pattern on a white ground and a blue majolica pot decorated with pink flowers and greeny brown leaves, the whole upon a blue tablecloth against a yellow background. There are in addition two oranges and three lemons. The result is a symphony of blue tones, animated by a scale of yellows ranging to orange. And I have another still-life: lemons in a basket against a yellow background. Besides this, a view of Arles. Of the town itself only a few red roofs and a tower are visible, the rest is hidden by the foliage of fig trees, all of it quite in the background, and a thin strip of blue sky above. The town is surrounded by meadows covered with dandelions,{B} a sea of gold. Right in the foreground a ditch which is full of purple irises cuts through the meadows. While I was busy painting this view, the grass was cut, that is why it is only a study and not the finished picture I intended it to be. But what a lovely theme—eh? A sea of yellow flowers with the reef of purple irises, and in the background the charming little town with its beautiful women!

I grow ever more and more convinced that the pictures which ought to be painted, the pictures which will be necessary and inevitable if painting is ever to attain to the serene heights of Greek sculpture, German music and French fiction, will be beyond the strength of one individual. They will therefore have to be executed by a group of painters, who will collaborate in order to carry out an idea which they hold in common. Suppose, for instance, that this man were a brilliant colourist who lacked ideas, while

another overflowed with a number of perfectly new, harrowing, or charming inspirations, which, however he did not know how to express adequately. This would be a sufficient reason to deplore the absence of *esprit de corps* among artists, who criticize and persecute one another, though fortunately without being able to exterminate their kind. You probably think this is all very trivial? Who knows? But the thing itself, the possibility of a Renaissance, is surely no trivial matter!

I often feel very sorry that I cannot induce myself to work more at home, from imagination. Imagination is surely a faculty that one should develop; for it alone enables us to create a more inspiring and comforting world than we can apprehend by means of a fleeting glance at reality, which is for ever changing and which vanishes like a flash of lightning. How glad I should be one day to try to paint the starry heavens as also a meadow studded with dandelions in the sunlight. But how can one ever hope to succeed in doing these things unless one resolves to stay at home and to work from imagination?

In painting I observe no system; I lash the canvas with irregular strokes and let them stand. Impasto—bare patches here and there—some places left quite unfinished—others overpainted—brutal touches, and the result is (at least I must assume that this is so) sufficiently disconcerting and irritating to displease people who have pre-conceived notions about technique. {C}

When I paint direct from nature, I always try to seize what is essential by means of line. Then I fill up the defined spaces (whether they have been expressed or not; for they have been felt at all events) with simple flat tones as follows: all ground or soil will contain the same violet tone, practically the whole of the sky will be kept blue in tone, while foliage will be blue-green or yellow-green (either the blue or the yellow may be deliberately intensified) in short, no photographic imitation, that is the chief thing!

Here is a question of technique for you! Just tell me your view of the matter! I wish to put black and white, as I buy them at the colourman's, boldly on my palette, and to use them as they are. If in a green park with pink footpaths, I see (please to remember that I have in mind the Japanese method of flat simple colouring) a man dressed in black—a magistrate, for instance, reading the "Intransigeant," and the sky above him is pure cobalt, why on earth should I not paint the said legal gentleman in pure black, and the "Intransigeant" in pure white?

For the Japanese pays no heed to the play of light, and paints flat tones one beside the other—characteristic lines, which seize the movement or the form in a simple manner.

Now, apropos of another idea: in a scheme of colour which contains a golden evening sky, for instance, one might at a pinch paint a crude white wall against the sky with pure white, or with the same crude white modified by a neutral tone; for the sky itself will lend it a pale mauve tinge.

In this very simple landscape, consisting of a completely white cottage (even the roof is whitewashed), standing on orange-coloured ground (for the southern sky and the Mediterranean both tend to produce very intense orange colouring, as their blue is very strong), the black note of the door, the window and the small cross on the roof makes a contrast of black and white, which is just as agreeable to the eye as the contrast of orange and blue.

On the same principle, here is another still more amusing theme: a woman in a black and white check dress, standing in the same simple landscape, with the sky blue, and the ground orange. The black and the white can quite adequately play the part of colours (at least, in many cases they may be considered as such), for their contrast is just as piquant as that of green and red, for instance. Moreover, the Japanese made use of the same tones; with magic beauty they render the dull pale complexion of a little girl and its fetching contrast with her black hair, by means of four strokes of the pen on white paper; and they do the same thing with their black bramble bushes, which they cover with countless white flowers.

At last I have seen the Mediterranean Sea and have spent a week in Saintes-Maries. I went there in the diligence, via la Camargue, through vineyards and meadows, and across plains, like those in Holland. In Saintes-Maries I saw some little girls who reminded me of Cimabue and Giotto—very much so, in fact; they were thin, rather sad, and mystic. On the beach, which is quite flat and sandy, I saw a number of green, red and blue boats, which were so delightful both in form and colour, that they made me think of flowers. One man alone can navigate a boat of this sort, but they do not go far out. They only venture into deep water when the wind is low and they return as soon as it rises.

I should also very much like to see Africa. But I will not make any definite plans for the future. Everything will depend upon circumstances. What I wanted to experience was the effect of a deep blue sky. Fromentin and Gérôme see no colour in the South, and a number of others are like them. But good Heavens!—if you take a little dry sand up in your hand and

hold it close to your eyes, of course it is colourless, just as water and air would be. There is no blue without yellow and orange, and when you paint blue, paint yellow and orange as well—am I not right?

I feel decidedly better in the South than in the North. I work even during the hour of noon, in the glaring sunlight, without a scrap of shade; and, believe me, I feel as happy as a cricket. Heavens! why did I not get to know this country at 25 instead of at 35 years of age! In those days, however, I was mad on grays, or rather on the absence of colour. I always dreamt of a Millet, and had my friends in the artistic circle of Mauve and of Israels, etc.

I have painted the "Sower." Oh, how beautiful the illustrations in the old calendars were!—with the hail, the rain, the snow and fine weather always rendered in the perfectly primitive manner which Anquetin favoured for his "Harvest."

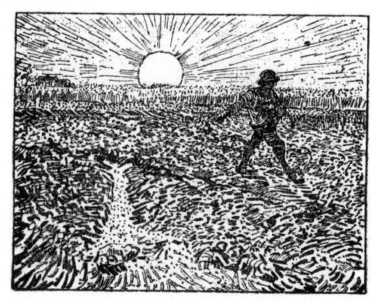

I may as well tell you that I do not dislike country life—for I grew up in the midst of it. Sudden recollections of old times and a longing for that infinite of which the "Sower" and the "Sheaf of Corn" are evidence, still enchant me now, just as they did formerly. But when shall I paint the starry heavens?—that picture which is always in my mind? Ah, what the worthy Cyprian says in J. K. Huysmans' "En' Ménage," is very true!—"The most

beautiful pictures are those of which one dreams when one is smoking a pipe in bed but which one never paints." And yet one must tackle such pictures, however incompetent one may feel in the presence of the inexpressible perfection and triumphant splendour of nature.

Here is another landscape for you!—A setting sun, a rising moon? In any case, a summer's evening. A violet city, yellow stars, a green-blue sky, crops of all colours, old-gold, copper, green-gold, red-gold, yellow-gold, yellow-bronze, green and red. I painted it in the midst of a North wind.

I should like to say the following about black and white:—take my "Sower"! The picture is divided into two halves, the upper portion is yellow and the lower portion violet. Now you observe that the white trousers are both restful and cheering to the eye while the strong and glowing contrast of the yellow and the violet might at the same time irritate it.

One reason for working is that the pictures are worth money. You will say, in the first place, that this reason is prosaic, and secondly that it is untrue. But it really is true. One reason for not working is that, in the first place, canvas and colour cost a lot of money. Drawings are the only things that can be produced cheaply.

My chief reason for being so fond of this part of the country is that here I am not in such fear of the cold which retards my circulation, and thus prevents me from thinking and doing anything at all. You will realize this only when you are a soldier and chance to come to these parts. Your melancholy will take wing,—for it is very probable that it is only the outcome of your having too little blood. And all this is the result of the confoundedly bad wine and infamous beef of Paris. Things had gone so far with me that my blood had almost ceased to circulate, or practically so in the true sense of the word. But here, in about a month's time, it began to flow again. And, my dear fellow, at that time I had a fit of melancholy like the one you have at present, and I would have suffered from it as much as you are suffering from yours, had I not greeted it joyfully as a sign of my recovery, which, by the by, was soon an established fact.

To paint and to love women are incompatible. This is really a confounded nuisance!

The symbol of St. Luke, the patron saint of painters, is as you know an ox. Thus one must be as patient as an ox if one would wish to cultivate the field of art. But how lucky oxen are to have nothing to do with this confounded business of painting!

But let me tell you this, that after your fit of melancholy you will feel fresher than you did before. Your health will grow stronger, and you will find the world about you so beautiful, that you will have but one wish—to

paint. I believe that your poetry will also change in the same way. After many eccentricities you will succeed {D} in producing things full of Egyptian repose and grand simplicity.

You will doubtless agree that neither you nor I can form a complete image of what Velasquez or Goya were as men and painters; for neither you nor I have seen Spain, their native land, and all the lovely pictures which have remained in the South. But this does not alter the fact that the little we do know is really very great indeed.

In order to understand the painters of the North, and above all Rembrandt, it is unquestionably of paramount importance to know and understand their country—and the somewhat petty and intimate history of their age, as well as the customs of their ancient fatherland. I must repeat that you and Baudelaire have not a sufficiently thorough knowledge of Rembrandt, and as for you, I still feel that I should like to induce you to make a long study of the greater and lesser Dutch Masters, before you form a definite opinion about them. For it is not a matter only of rare and costly jewels, one has to select precious stones from out a mass of precious stones, and many a false diamond will be found among genuine specimens. Thus, although I have studied the schools of my fatherland for over twenty years, a discussion concerning the painters of the North is usually conducted in such a false spirit, that I should in most cases hold my peace whenever the conversation chanced to turn upon them.

I can only urge you, therefore, in Heaven's name, to examine them a little more thoroughly; your trouble will be repaid a thousandfold.

If, for instance, I declare that the Ostade of the Louvre, representing the family of the artist—the man himself, his wife and his ten children—like the "Congress' of Münster," by Terborch, is a picture which though infinitely worth being studied and deeply thought about [is sadly neglected];[24] and that precisely those pictures in the Louvre collection which I particularly value and regard as the most remarkable, are very often overlooked by artists—even by those who come on purpose to see the Dutch School—these mistakes do not surprise me. For I know that my choice is based upon specialised knowledge which the majority of French people cannot acquire. If, however, I disagree with you on these points, I am nevertheless convinced, that in time to come you will share my view of the matter.

What always makes me so desperate in the Louvre, is to be compelled to look on while the asinine authorities allow their Rembrandts to be spoilt, and ruin so many beautiful pictures.

For the disagreeable jaundiced tone of some of the Rembrandts is the result of discolouration brought about by dampness or other causes (heating, dust, etc.), a thing I could easily prove to you.

And that is why it is just as difficult to ascertain Rembrandt's colouring as it is to discover accurately what greys were used by Velasquez. For the want of a better expression one might overcome the difficulty by speaking of Rembrandt's gold; but it is very vague.

When I came to France I learnt to understand Delacroix and Zola perhaps better than many a Frenchman. And my admiration for both of these men is now as unbounded as it is sincere. Armed with an almost complete mastery of Rembrandt, I discovered that Delacroix obtained his effects by means of his colour, and Rembrandt by means of his values; but they are worthy of each other.

Zola and Balzac, who are, among other things, the painters of a whole epoch, afford their admirers many rare artistic delights owing to the fact that they express the whole of the age which they describe.

Even though Delacroix paints only mankind and life, instead of a whole age, he belongs none the less to the class of universal geniuses. I particularly like the closing words of an article which, if I am not mistaken, was written by Théophile Silvestre, who ended a hymn of praise as follows: "Thus, almost with a smile on his lips, did Eugène Delacroix die. A noble painter, he bore the sun in his head and a tempest in his heart, and he could turn from warriors to saints, from saints to lovers, from lovers to tigers, and from tigers to flowers."

Daumier is also a great genius, while Millet is likewise the painter of a whole generation and of its atmosphere. Maybe, these great geniuses are a little crazy, and it is possible that we may be a little crazy too, to have such faith in them and to feel such unbounded admiration for their art. If this be so, I prefer my folly to the cold wisdom of others.

Perhaps the most direct way is to study Rembrandt. But, first of all, let me tell you something about Franz Hals, who has never painted the Saviour, the Angel announcing Christ's birth to the shepherds, the Crucifixion or the Resurrection, and who has never painted naked, voluptuous, or cruel{E} female figures.

He always painted portraits and nothing else—soldier pictures, officers' banquets, portraits of magistrates assembled to discuss affairs of

State, and portraits of matrons with pink or sallow complexions, wearing white caps and dressed in black wool or satin, discussing the budget of an orphanage or a hospital.

He also painted a drunken toper, an old fishwife as a lively witch, a beautiful Bohemian courtesan, unweaned babies in arms, and an elegant{F} cavalier—a *bon-vivant*, with a bristly moustache, top-boots, and spurs.

He painted himself and his wife as young lovers, sitting on a grassy bank in the garden, after the wedding night.

He painted tramps and laughing street-boys, musicians, and a fat cook.

We cannot do anything else; but all this is worthy of Dante's "Paradise," the masterpieces by Michelangelo and Raphael, and even the Greeks; it is as beautiful as Zola, but more healthy and more cheerful, though equally true to life. For the age of Hals was healthier and less wretched. What then is Rembrandt? Precisely the same, a portrait painter! One must first have this sound, clear and comprehensive idea of these two Dutch masters, who are worthy of each other, and then one can enter more deeply into this subject. If one can picture the whole of this glorious state, revealed in grand outline by both of these prolific portrait painters, plenty of room is left for the landscapes, interiors, pictures of animals and philosophical subjects. But I implore you to follow my reasoning closely; I am trying to make it as simple and as clear as possible.

Let every corner of your brain be permeated with that master, Franz Hals, who painted the portraits of an entire, important, living, and immortal state. Also let every corner of your brain be permeated with that other by no means minor great master of the Dutch state, Rembrandt van Ryn, a man of mighty gifts, and just as naturalistic and healthy as Hals. And now from this source—Rembrandt, we see arise as direct and genuine pupils: Jan van der Meer of Delft, Fabritius, Nicholas Maës, Pieter de Hooch, Bol; as also such artists as Potter, Ruysdael, and Ostade, who are under his influence. I have mentioned Fabritius to you, only two of whose pictures we possess. But in all this I have not referred to a whole host of good painters, and above all not to the false diamonds. And it is precisely with these spurious stones that the French man in the street is best acquainted. Have I made myself clear? I have tried to reveal the great and simple fact: the painting of mankind, or, preferably, of a whole state, by means of portraits. Much later we shall have to deal with magic art, with the pictures of Saviours and of nude women—these things are extremely interesting, but they are not everything.

I do not think that the question of the Dutch masters which we raised a day or two ago, is without interest. In all matters of humanity, originality, or naturalism, it is very interesting to consult them. But, in the first place, I must speak about you and two still-life pictures you have painted, as also two portraits of your grandmother. Have you ever succeeded better in anything else? Were you ever more yourself, more individual, in any other work? My answer is No! The thorough study of the first subject, the first person, that was at hand, sufficed to make you work with earnestness. Do you know what it was that made these three or four studies so valuable to me? Something inexplicably arbitrary, something very clever, deliberate, firm and self-reliant—that is what it was. Never, dear friend, have you been closer to Rembrandt than while painting those studies. It was in Rembrandt's studio, under the eyes of that incomparable Sphinx, that Vermeer of Delft found that extraordinarily sound technique which was never to be surpassed, and which people are so ardently longing to find to-day. I know, of course, that we are now engaged in the problem of colour, whereas they were concerned with chiaroscuro and values. But what do these slight differences matter when that which is, above all, necessary is to be able to express oneself with vigour and strength?

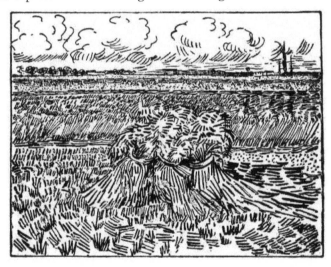

At the present moment you are investigating the technique of the early Italians and Germans, and the question of the symbolic significance which the spiritualized and mystic painting of the Italians may possess—by all means continue!...

A certain anecdote about Giotto strikes me as being very neat. There was a prize competition opened for the best picture of the Virgin, and a host of sketches were sent in to the judging committee of fine arts of the day. The one signed by Giotto was a simple oval, a plain, egg-shaped space.

The jury entirely confident, although perplexed, gave Giotto the commission for the picture. Whether it is true or not, I like the story.

Now, however, let me return to Daumier and to the portrait of your grandmother. When will you again send us studies of such sterling value? I urge you most earnestly to do so, although I by no means underestimate your attempts at line composition, and am far from indifferent to the effect of contrasted lines and forms. The trouble is, my dear old Bernard, that Giotto and Cimabue, like Holbein and Van Eyck, lived in an atmosphere of obelisks—if I may use such an expression—in which everything was arranged with architectural method, in which every individual was a stone or a brick in the general edifice, and all things were interdependent and constituted a monumental social structure. If the Socialists construct their edifice in the same logical manner—a thing they are very far from doing— the above-mentioned order of society will certainly come back to life in a similar way. But we, you know, live in the midst of complete *laisser-aller* and anarchy; we artists who love order and symmetry, isolate ourselves and work at introducing a little style into some particular portion of the world.

Puvis knew this very well, and when—clever and honest man that he was—he forgot his Elysian fields, and descended into our age, he painted a very beautiful portrait, "The Jovial Old Man"—a figure of a man sitting in a blue room, reading a yellow covered book, with a glass of water, containing a water-colour brush and a rose, at his side. And he also painted a stylish lady such as the Goncourts might have described.

Yes, the Dutch painted things as they were, certainly without reflecting much upon them; as Courbet painted his naked beauties, so they painted portraits, landscapes and still-life subjects. And it is not by any means the most foolish way. But if, owing to the fact that we do not know what to do, we imitate them, we do so only to avoid squandering our modest powers in fruitless metaphysical brooding which cannot press chaos into a tumbler; for that is precisely why it is chaos, because it cannot enter into a tumbler of our calibre.

We are only able—and this is just what these Dutchmen did, who for people with a system were infernally clever,—to paint an atom out of the chaos: a horse, a portrait, a grandmother, apples or a landscape. {G}

Degas' painting is manly and impersonal simply because, for his part, he was content to be a simple *bourgeois* who did not wish to have anything to do with the enjoyment of life. All around him he saw human animals ... living and enjoying themselves, and he painted them well, because, unlike

Rubens, he made no pretensions of being a good cavalier or a society man....

Yes, yes, Balzac, that great and powerful artist, said quite rightly that the modern artist is strengthened by being, relatively speaking, chaste. The Dutchmen were married and begat themselves children. That is a fine, in fact a very fine way of filling a life, and quite a natural way too!... One swallow does not make a summer. There may be a good deal of virility in your new Brittany studies; but I am unable to judge as I have not yet seen them. However, I have already seen virile works of yours—the portrait of your grandmother and the still-life. To judge from the drawings I have a slight suspicion that your new Brittany studies do not possess the same power, regarded precisely from the standpoint of virility.

The studies which I mentioned first constitute the spring of your artistic life. If we wish to keep all our strength for our life-work, we must only have very little to do with women and according as our temperament demands, live either like soldiers or monks. For the Dutchmen led a peaceful, quiet and well-ordered life. Delacroix—ah! he was a fine fellow— he used to say: "I discovered the art of painting when I no longer had any more teeth or breath." And those who had seen him painting said: "When Delacroix paints, he looks like a lion devouring a piece of flesh." He had very little to do with women, and indulged only in loose love affairs{H} so as not to waste any of the time consecrated to his life's task. To judge from the opinions expressed in this letter, it would appear to be less in keeping than I should like it to be with our correspondence and friendship of former years; but if from its contents you gather that I am rather anxious about your health, you are right. I know that the study of the Dutchmen must be beneficial; for their works are so full of virility, power and health.

A short time ago I discovered a small etching by Rembrandt and I bought it. It was of a nude figure of a man, realistic and simple. He stands leaning against a door or a pillar, in a dark room, and a ray of sunshine from above strikes the bowed head and its abundant red locks. The body is conceived with so much truth, and is so vigorous,{I} that it almost reminds me of Degas.

I say, have you carefully studied "The' Ox," or "The Inside of a Butcher's Shop" at the Louvre? I doubt it. I should really greatly enjoy spending a morning with you in the Dutch Galleries. These things are hard to describe; but in front of the actual pictures I could call your attention to such splendid and wonderful things, that beside them the very Primitives themselves take a second place in my admiration. But then I have such a very slight strain of eccentricity in my composition!

A Greek statue, a peasant by Millet, a Dutch portrait, a naked woman by Courbet or Degas; it is beside the serene and elaborate perfection of these things that the works of the Primitives and the Japanese seem only like written characters as compared with painting. It really interests me immensely, but a complete work of art, a piece of perfection enables us to conceive infinity; and to enjoy beauty to the full{J} gives one a feeling of eternity.... Do you know a painter called Jan van der Meer? He painted a very distinguished and beautiful Dutch woman, in pregnancy. The scale of colours of this strange artist consists of blue, lemon-yellow, pearl-grey, black and white. It is true, in the few pictures he painted the whole range of the palette is to be found; but it is just as characteristic of him to place lemon-yellow, a dull blue, and light grey together, as it is of Velasquez to harmonize black, white, grey and pink. Of course the Dutch painters are too widely distributed over the Museums and collections of the world for us to be able to form any adequate idea of their work, and this is still more difficult when one knows only the Louvre. And yet it is precisely the Frenchmen, Ch. Blanc, Thoré and Fromentin, who have written the best things about them.

The Dutchmen had no imagination, but they had tremendous taste and an unerring sense of composition; they painted no pictures of the Saviour or of the Saints.... Rembrandt did! That is true; but he is the only one, and even with him pictures containing a genuine Biblical feeling are comparatively rare occurrences;{K} he was the only one to paint pictures of Christ, etc. But his pictures resemble no other kind of religious painting; in his case it is a sort of metaphysical sorcery.

This is how he painted angels: He made a portrait of himself, toothless and with a cotton cap on his head.

The first picture he painted from nature, by means of a looking glass. He dreamt and dreamt, and his hand painted his portrait once again, but from imagination, and the impression became more harrowed and more harrowing.

Second picture. He continued to dream and dream and, how it happened I do not know, but just as Socrates and Muhammed had their guardian spirits, behind the hoary patriarch who is not unlike himself, Rembrandt painted an angel with the enigmatical smile of a head by Leonardo....[25]{L} But now I am calling your attention to an artist who dreams and works from his imagination, after having declared that the characteristic feature of the Dutch painters is that they have no inventive genius and no imagination. Am I therefore illogical? No! Rembrandt invented nothing; he knew and felt this angel and these peculiar saints perfectly well.

Delacroix painted a crucified Christ for us, by setting, quite unexpectedly, a light lemon-yellow tone on the canvas. This vivid note of colour lent the picture that indescribable and mysterious charm as of a solitary star in a dark evening sky. Rembrandt works with values in the same way as Delacroix does with colours. A long distance, however, separates Delacroix' and Rembrandt's methods from those of all the rest of religious painting.

I have just finished the portrait of a little girl of twelve. Her eyes are brown, her hair and eyebrows are black, she has an olive skin, and stands before a white background containing a strong tinge of emerald green, in a blood-red jacket with violet stripes, a blue skirt with large orange-coloured spots, and an oleander flower between her dainty little fingers. This study has exhausted me to such an extent that my head does not feel like writing.

The Bible is Christ, for the Old Testament works up to this climax. St. Paul and the Evangelists live on the other side of the Mount of Olives. How small this history is! Heavens! here it is in a couple of words. There seem to be nothing but Jews on earth—Jews who suddenly declare that everything outside their own race is unclean. Why did not all the other Southern races under the sun—the Egyptians, the Indians, the Ethiopians, the Assyrians and the Babylonians—write their annals with the same care? It must be fine to study these things, and to be able to read all this must be about as good as not being able to read at all. But the Bible which depresses us so much, which rouses all our despair and all our deepest discontent, and whose narrow-mindedness and parlous folly{M} tear our hearts in two, contains one piece of consolation like a soft kernel in a hard shell, a bitter core, and that is Christ. The figure of Christ, as I conceive it, has been painted by Delacroix and Rembrandt, and only Millet painted Christ's teaching. At the rest of their religious painting I can only smile commiseratingly—not from the religious but from the pictorial standpoint. The early Italians, Flemings and Germans are, in my opinion, pagans, who interest me only as much as Velasquez and so many other naturalistic painters do.

Of all philosophers, sages, etc., Christ was the only one whose principal doctrine was the affirmation of immortality and eternity, the nothingness of death, and the necessity and importance of truth and resignation{N}. He lived serenely as an artist, as a greater artist than any other; for he despised marble, clay and the palette, and worked upon living flesh. That is to say, this marvellous artist, who eludes the grasp of that

coarse instrument—the neurotic and confused brain of modern man—created neither statues nor pictures nor even books; he says so himself quite majestically—he created real living men, immortals. That is a solemn thing, more particularly because it is the truth. This great artist, then, wrote no books. There can be no doubt that Christian literature, on the whole, would only make him indignant. For how seldom is anything to be found among its productions that could find favour beside the Gospel of St. Luke and the Epistles of St. Paul, which are so simple in their austere and warlike form? But even if this great artist, Christ, scorned to write books about his ideas and sensations, he certainly did not despise either the spoken word or still less the parable. (What vigour there is in the parable of the sower, the harvest, and the fig tree!) And who would dare tell us that he lied when, in predicting the downfall of the Roman State, he declared: "Heaven and earth shall pass away: but my words shall not pass away."

These spoken words which he, as a *grand seigneur* did not even think it necessary to write down, are the highest pinnacle ever attained by art; in such pure altitudes art becomes a creative force, a pure creative power.

Such meditations lead us far afield, very far afield (they even elevate us above art). They give us an insight into the art of moulding life, and of being immortal in life itself, and still they are not unrelated to painting. The patron saint of painting, St. Luke—doctor, painter and evangelist, whose device, alas! is an ox—is there to give us hope. But our true and real life is really a humble one; we poor unhappy painters are vegetating beneath the besotting yoke of a craft which is barely practicable on this ungrateful planet, whereon the love of art makes us unable to taste of real love.

As, however, there is nothing to gainsay the supposition that there are similar lines, colours and forms on innumerable other planets and suns, we may be allowed to retain a certain amount of good spirits in view of the possibility that we shall be able to paint among higher conditions and in another and different life, and that we shall reach that life by a process which perhaps is not more incomprehensible or surprising than the transformation of a caterpillar into a butterfly, or of a grub into a cockchafer. The scene of this existence for the painter-butterfly could be one of the innumerable stars which, when we are dead, might perhaps be as accessible to us as are the black spots that in this terrestrial life represent the cities and towns on our maps.

Science! Scientific reasoning seems to me to be a weapon which with time will develop in quite an unsuspected manner; in the old days, for instance, the world was supposed to be flat. This was perfectly right too. It is still flat between Paris and Asnières. This, however, does not alter the fact that science proves the earth to be round—a fact no one any longer

disputes. Now, in the same way, it is assumed that human life is flat and that it leads from birth to death. Probably, however, life also is round, and much vaster in its extent and its capacities than we have suspected heretofore. Later generations will probably enlighten us concerning this interesting problem, and then possibly science might—with all due respect to her—come almost to the same conclusions as those which Christ summed up in his doctrine concerning the other half of life. However this may be, the fact remains that we painters are living in the midst of reality, and that we should breathe our spirit into our creations as long as we ourselves continue to breathe. {O}

Oh, what a beautiful picture that is of Eugène Delacroix—"Christ on the Lake of Gennesaret!" He, with his pale yellow halo—asleep and luminous, bathed in a glow of dramatic violet, dark blue, reddish blue—and the group of frightened disciples upon the terrible viridian sea, with waves reaching up to the top of the frame. What a splendid conception!

I would make a few sketches for you were it not for the fact that I have just been busy with a model for three days—drawing and painting a Zouave—and simply cannot do anything more. Writing, on the other hand, rests and distracts me. What I have done is hideous; a drawing of the Zouave sitting; then an oil sketch of him against a perfectly white wall; and then a portrait of him against a green door and a few yellow bricks of a wall—it is all hard, ugly, and badly done. Albeit, as I tackled real difficulties in its production, it may pave the way into the future. Any figure that I paint is generally dreadful even in my own eyes, how much more hideous it must be therefore in other people's! And yet one derives most experience from the study of the figure, when one sets about it in a manner that is different from that which M. Benjamin Constant used to teach us, for instance. I say, do you remember Puvis de Chavannes' "John the Baptist"? I think it is simply wonderful and just as magic as Eugène Delacroix' work.

My brother-in-law is at present holding an exhibition of Claude Monet's work—ten pictures painted at Antibes between February and May. It appears that it is extraordinarily beautiful. Have you ever read the life of Luther? It is necessary to do this in order to be able to understand Cranach, Holbein and Dürer. He and his powerful personality are the high light of the Renaissance. If ever we happened to be in the Louvre together I should very much like to see the Primitives with you. At the Louvre my greatest love is, of course, the Dutch school, Rembrandt above all, whom I studied so much in the past. Then Potter. Upon a surface from about four to six metres he gives you a white stallion, neighing passionately and desperately, with a dark and stormy sky above it, and the animal sadly isolated upon a

pale green infinity of moist meadow land. Altogether there are glories to be found in these Dutchmen, which can be compared with nothing else.

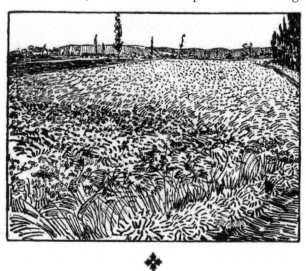

To-day I am sending you one or two sketches painted from oil studies. In this way you will become acquainted with themes drawn from the nature which inspired old Cézanne. For the *Crau* near Aix is much the same as the country in the neighbourhood of Tarascon and the *Crau* of this district. Camargue is even simpler still, for there vast stretches of waste ground are covered with nothing but tamarind bushes and stiff grasses, which bear the same relation to these lean meadows as alfa grass does to the desert.

As I know how very fond you are of Cézanne, I thought that these sketches from Provence would please you. Not because there is any trace of resemblance between my drawings and Cézanne's—God forbid that I should mean that—any more than there is between Monticelli and myself; but I passionately love the same country as they loved so much, and for the same reasons—the colouring and the definite drawing.

When I used the word "collaboration" some time ago I did not mean that two or three painters should work at the same picture, but that they should each produce different works which nevertheless should belong to and complete one another. Look at the early Italians, the German Primitives, the Dutch School, and the later Italians—do not all their works together quite involuntarily constitute a group, a series?

As a matter of fact, the Impressionists also constitute a group, despite all their wretched domestic warfare, in which both sides, with an enthusiasm worthy of a better cause, endeavour to eat each other up. In our

northern school Rembrandt is lord and master, for his influence is felt by every one who approaches him. For instance, we find Paul Potter painting animals at rut, and passionate, in storm, sunshine, and the melancholy of autumn; while this same Potter, before he knew Rembrandt, was dry and feeble.

Rembrandt and Potter are two men who are as closely related as brothers, and even if Rembrandt never put a brush stroke on Potter's pictures, Potter and Ruysdael nevertheless have to thank him for all the best qualities their work possesses—that intangible something which thrills us to the core when we succeed in recognizing a corner of old Holland *à travers leur tempérament.*

Besides, the material difficulties of the painter's life render something in the way of collaboration and combination between artists a very desirable thing (such as existed at the time of the St. Luke Guilds);[26] for if only they would appreciate each other as good comrades instead of being always at logger-heads, they might considerably alleviate one another's difficulties. Painters would then be happier, and, in any case, less ridiculous, foolish and vile. But—I don't wish to insist on this point—I know well enough at what a frantic pace life travels nowadays, and that one has not the time to discuss things and to act as well. And that is why, in view of the remoteness of any possible artistic association, we painters are now in mid-sea, and are sailing alone in our wretched little craft, on the great billows of our age. Is it an age of development{P} or of decay? We cannot judge of this; for we are too closely connected with it to be able to avoid being led astray by the distortions of perspective. Contemporary events probably assume exaggerated proportions in our eyes, whether they be to our advantage or disadvantage.

I have had another very busy day to-day. I wonder what you would say about my present work? In any case you would seek in it in vain for Cézanne's conscientious and almost timid brush stroke. As, however, I am painting the same stretch of country, La Crau and La Camargue, although from a somewhat different standpoint, you might after all find some of my colouring reminiscent of his work. How do I know? At times I have thought involuntarily of Cézanne, when I happened to recall his clumsy brush-strokes (excuse the word "clumsy") in many a study which, probably, he painted in a strong north wind. As half the time I have to contend with the same difficulties, I can understand how it is that Cézanne's brush-stroke is sometimes firm and steady, and at other times clumsy—his easel shook. Once or twice I have worked at a mad speed; if it is wrong to do so, I cannot help it. For instance, I painted "The Summer Evening," on a canvas

about 35 in. by 35 in.[27] at one sitting. Could I work on it again?—Impossible! Why should I spoil it?—more particularly as I set out to paint it in the midst of a strong north wind. Are we not much more keenly in search of strength of conception than of sober brush-work, and, after all, is it always possible to work in a quiet and perfectly regular manner when painting a study which is a first impression, on the spot itself, and from nature?

'Pon my soul, this would seem to me just as impossible as in fencing.{Q}

If only painters could unite in order to collaborate in the production of great things! The art of the future might then give us examples of their work. For the execution of their pictures, painters would then have to collaborate, in order to be able to bear the material difficulties. Unfortunately, however, we are not so far advanced, things do not go so fast with the fine arts as with literature. To-day, like yesterday, I am writing to you in great haste, and quite exhausted with work. For the moment I do not feel equal to making any drawings, my morning in the fields has worn me out completely. How this southern sun fatigues one! I am quite incapable of judging my own work; I cannot see whether my studies are good or bad. I have painted seven studies of corn; unfortunately, quite against my will, they are only landscapes. They are all of a yellow tone, and were executed at a frantic speed, just as the reaper works silently in the sweltering sun, with only one thought in his mind—to cut down as much as possible.

I can well understand that you were a trifle surprised to hear how little I liked the Bible, although I have often tried to study it more thoroughly. Only its kernel—Christ—seems to me, from an artistic point of view, to stand higher than, or at any rate to be somewhat different from Greek, Indian, Egyptian, and Persian antiquities, although these also stood on a very high plane. But, I repeat, this Christ is more of an artist than all artists—he worked in living spirits and bodies—he made men instead of statues. When I think of this I feel a regular beast in the field; for am I not a painter? And I admire the bull, the eagle, and man with such an intense adoration, that it will certainly prevent me from ever becoming an ambitious person.

I grow ever more and more convinced that cooking has something to do with our capacity for thinking and for painting pictures. I know, for instance, that if my digestion is upset, my work does not by any means improve. In the south the powers of the senses are intensified; one's hand is more nimble, one's eyes are more acute, and one's brain is clearer. All this, of course, on condition that no dysentery or any other indisposition arises

to spoil everything and to pull one down. On this account, I venture to declare, that he who would fain devote himself to artistic work will find his capacities increase in the South.

Art is long and life is fleeting, and one must try with patience to sell one's life as dearly as possible. I should like to be your age, and, with all I know, to go to Africa to serve as a soldier there. In order to work well, one must be well lodged, well fed, and able to smoke one's pipe and drink one's coffee in peace. I do not wish to imply that there are not many other good things; let everyone do as he pleases; but my system seems to me better than many others.

Almost at the same moment as I was dispatching my studies, Gauguin's and your parcel arrived. I was overjoyed, my heart became really all aglow when I saw your two faces. Your portrait, as you must know, pleased me greatly. But you don't require to be told that I like everything you do. Before I came on the scene nobody, perhaps, appreciated your work as much as I do now. Let me urge you to make a special study of portrait painting; work at it as hard as you can and do not give in; we must in time conquer the public by means of the portrait—in my opinion the future lies there. But do not let us become involved in hypotheses.

I have ruthlessly to destroy a large picture of Christ with the angel in Gethsemane, and another representing a poet standing under the starry heavens; for, although the colour was good in both, the drawing was not studied in the first place from the model, which in such cases is essential.

Maybe, my last studies are not impressionistic at all, but that I cannot help. I paint what I paint, in complete subjection to nature, and without thinking of anything else.

I cannot work without models. I do not mean that I never turn my back boldly upon nature ...;{R} but I am frightened to death of losing accuracy of form. Perhaps later on, after ten years of study, I shall try; but really and truly, I am so devoured by curiosity for the possible and the actual, that I have neither the wish nor the courage to seek an ideal which could arise out of my abstract studies. Others may be more gifted for the painting of abstract studies, and you are certainly one of these, as is also Gauguin. Maybe, I shall be the same, some day, when I am old; meanwhile I feed on nature. At times I do indeed exaggerate or alter a theme; but I never invent a whole picture—on the contrary, I actually find it at hand and complete—all I have to do is to extract it from nature.

My house will seem less empty to me now that I have these pictures of you both. How glad I should be to have you here, even this winter! It is true that the journey is rather expensive. But could we not risk the expense and try to recover it by painting? In the winter it is so difficult to work in the North. Possibly it is so here, as well; I cannot speak from experience on this point. I shall have to wait and see; but the better to understand the Japanese it is deuced necessary to know the South, where life is led more in the open air. Besides this, a good many places here have something mysteriously sublime and noble about them, which would please you immensely.

I ought to have sent you some sketches long ago, in return for those you sent me. But just lately, during the lovely weather, I have been wholly occupied by a few canvases about 36 in. by 27½ in. in size,[28] which simply exhaust me, and which I intend using for the decoration of my house.

If your father had a son who sought and found gold in stones or on the pavement, he would certainly not think lightly of this talent. Well, in my opinion, you possess a talent which is, at least, equally valuable. Your father might deplore the fact that what you found was not brand new and glittering gold, already stamped like the coin of the realm; but he would, nevertheless, collect all your findings and sell them only at a good price. Well, then, that is what he should do with your pictures and drawings, which are just as valuable as marketable commodities as stones or metal; for to paint a picture is just as difficult as to find a small or large diamond. At present the world recognizes the value of a gold piece, or of a genuine pearl. Unfortunately, however, those who paint pictures and those who believe in the painting of pictures, are extremely rare. Still there are a few such people, and in any case we cannot do better than bide our time patiently, even though we have to wait a long while.

The idea of forming a sort of freemasonry among artists does not please me particularly; I am a great enemy of all regulations and institutions, etc. I am in search of something very different from dogmas, for they never by any chance set things in order, and only lead to endless disputes. That is a sign of decay. As, for the present, a union of painters exists only in very vague outline why not leave things as they are at least provisionally? It is much nicer when an organization of the sort we have in our minds crystallizes all of its own accord. The more things are discussed, the less will be done. If you wish to take a part in helping the cause, all you have to do is to continue working away with me and Gauguin; the affair is now started; do not let us say a word more about it. If it is to come it will do so without any elaborate negotiations, but simply by means of calm and well-considered action.

I am sending five studies, and must also include at least two attempts at somewhat more important pictures—a portrait of myself and a landscape painted in a most terrible north wind. There are also a study of a small garden with flowers of all colours, a study of grey, dusty coal, and finally another still life, "A Pair of Peasant's Shoes," and a little landscape, a trifle, just a small stretch of country.

In the event of these studies not meeting with any appreciation, and one or the other of our friends not being able to take a fancy to any of them, please keep those that are liked and return the others together with the pictures sent in exchange for those that are retained.

There is no hurry, and when business is done by barter, it is but right and proper for both sides to try and offer only good work.

If in the morning it is sufficiently dry to be rolled up, I shall also send you a landscape containing figures unloading sand, and in addition to that the rough sketch of a picture which is full of a mature will.

What about the gentleman so diligently engaged in art whom I found in your last letter, and who looked so like me—was he supposed to be me or somebody else? As far as the face is concerned he looks very like me; but in the first place I always smoke a pipe, and then I positively dread sitting on a thin ledge of rock overlooking the sea, for I suffer from giddiness. In

the name of these presents I therefore protest most solemnly against the other resemblances I have already mentioned.{S}

❖

The decoration of my house is absorbing me entirely, and I hope and believe that it will be very tasteful even if it be very different from everything you do.

That reminds me that on one occasion some time ago you spoke to me of certain pictures which were to represent flowers, trees, and fields, respectively. Now I have the "Poet's Garden" (two canvases), the "Starry Night," the "Vineyard," the "Furrows," the "View from my House," which might also be called "The' Street." As you see, without any intention on my part, a certain natural sequence seems to connect them together.

I should be very curious to see sketches of Pont-Aven; but you must send me a more finished study. You are, however, sure to do everything in the best possible way; for I am so fond of your talent that in time I shall make quite a little collection of your works. I have always been very much moved by the thought that Japanese artists often bartered their pictures among themselves. That does indeed show that they loved one another and were united, that a kind of harmony prevailed among them, and that they lived in brotherly concord instead of in intrigues. The more we resemble them in these things the more we shall prosper. It also appears that a few of these Japanese artists earned very little money and lived like simple workmen. I have the reproduction of a Japanese drawing (Bing's publication) representing a single blade of grass. What a paragon of conscientiousness it is! I shall show it to you when I get the chance.

❖

What surprised me in your letter were your words: "Ah, as for painting Gauguin's portrait—that is impossible!" Why impossible? That's all nonsense. But I will not press you further. And has not Gauguin, for his part, ever thought of painting your portrait? You are a funny pair of portrait painters, I must say! You live all day long shoulder to shoulder and cannot even agree so far as to act as each other's models. The end of it will be that you will part without having painted each other's portraits. All right, I will not urge you any more. But I hope that one day I shall be able to paint both your portrait and Gauguin's. I shall do it as soon as we all come together, which is sure to happen some day.

❖

Whereas the finest plans and calculations so often come to naught, if only one work on the off chance and take advantage of the happy accidents the day brings with it, one can accomplish a host of good and astonishing things. Make a point of going to Africa for a while—you will be enraptured with the South, and it will make you a great artist. Even Gauguin is greatly indebted to the South for his talent. {T}

For many months now I have been contemplating the strong sun of the South, and the result of this experiment is that, in my opinion, and chiefly from the standpoint of colour, Delacroix and Monticelli, who are now wrongly reckoned among the pure romanticists and the artists with fantastic imaginations, are entirely justified. Think of it, the South which Fromentin and Gérome have depicted so dryly, is even in these parts a land the intimate charm of which can be rendered only with the colours of the colourist.

In my sketch of "The' Garden," there may be something like *Des tapis velus—de fleurs et verdure tissus.* I wished to reply to all your quotations with the pen, even if I dispensed with words. My head does not feel very much like discussing to-day; I am head over ears in work. I have just done two large pen-drawings, for instance, a bird's-eye view of an endless plain seen from the top of a hill: vineyards, and fields of stubble reaching to infinity, and extending like the surface of the sea to the horizon, which is bounded by the hills of *La Crau.* It does not look Japanese, and yet, truth to tell, I have never painted anything so essentially Japanese. A tiny figure of a labourer and a small train running through the cornfields, constitute the only signs of life in the picture. Think of it! on one of my first days at this place, a painter friend of mine said to me: "It would be absurdly tedious to paint that!" I did not attempt to answer, but thought the spot so beautiful that I could not even summon the strength to upbraid the idiot. I returned to the locality again and again, and made two drawings of it—this flat stretch of country which contains nothing save infinity, eternity. And then, while I was drawing, a man walked up to me—not a painter this time, but a soldier. "Does it surprise you," I asked him, "that I should think this as beautiful as the sea?" "No, it does not surprise me in the' least that you should think this as beautiful as the sea," came the reply (the fellow knew the sea, by-the-bye); "for I think it even more' beautiful than the ocean, because it is inhabited."

Which of the two men understood the most about art, the painter or the soldier? According to my way of thinking, the soldier did; am I not right?

I want to paint humanity, humanity and again humanity.

I love nothing better than this series of bipeds, from the smallest baby in long clothes to Socrates, from the woman with black hair and a white skin to the one with golden hair and a brick-red sun-burnt face. Meanwhile I am painting other things.

But among my studies I have one of a figure which is a perfect continuation of my Dutch pictures. On one occasion I showed these to you, together with various other pictures of my Dutch days, the "Potato-Eaters," etc., and I should like you to see these as well. They are all studies in which colour plays such an important part that the black and white of a drawing could not give you any idea of them. I had actually thought of sending you a very large and careful drawing of the one in question. But, however accurate it might be, it would result in something totally different; for colour is the only thing that can suggest the effect of the hot parched air of a midsummer's day at noon, in the midst of harvest-making; and if this effect is lacking, the whole picture is altered. You and Gauguin know what a peasant is, and how much of the beast must lie in his constitution if he belong to the right race.

Oh, how the gorgeous sunlight gets to one's head here in the country! I do not doubt but what it can drive a man a little crazy. As, however, I was already a little inclined that way, now I have only the enjoyment of it.

I am thinking of decorating my studio with half a dozen sunflowers. It will be a decorative effect in which the glaring or broken tones of chromes will stand out vividly against a background of variegated blue, ranging from the most delicate emerald green to royal blue, enclosed in narrow strips of golden yellow. It will produce the sort of effect that Gothic church-windows do.

Oh we crazy-pates! What joys our eyes give us—don't they? Nevertheless nature takes her revenge on the animal in us, and our bodies are pitiable, and often a terrible burden. This has been so ever since the time of Giotto, who was a sickly sort of man. But what a delightful sight and what amusement we get from the toothless laughter of that old lion, Rembrandt, with a cloth round his head and his palette in his hand.

FURTHER LETTERS TO HIS BROTHER

THE city of Paris does not pay. It would break my heart to see Seurat's pictures buried in a provincial museum or in a cellar; they ought to remain in living hands. If T. were only willing!...

If the three permanent exhibitions are established an important work of Seurat's will be required for each of the following places—Paris, London and Marseilles.

How kind it is of you to promise G. and myself to make the realization of the projected union a possible thing! I have just received a letter from B., who for the last few days has been on a visit to G., L., and another man in Pont-Aven. In this letter, which, by-the-bye, is very friendly in tone, there is not a single word about G.'s having the intention of joining me here, nor is there any hint that they are expecting me there. Nevertheless the letter is a very friendly one. I have not received a line from G. himself for a month. I really believe that G. prefers to come to an understanding with his friends in the North, and if he have the good fortune to sell one or more pictures, he will probably no longer wish to join me here.

Whether G. comes or not is his affair; for, provided that we are ready to receive him, and that his bed and his quarters are prepared, we shall have kept our promise. I insist upon this, because, in so doing, my object is to release myself and a friend from the evil that thrives on our work, and that is the necessity of living in expensive hotels without our deriving any advantage from the arrangement—which is sheer madness. The hope of being able to live without money troubles, and of one day escaping from these eternal straits—what a foolish illusion this is! I should consider myself lucky to be able to work even for an annuity which would only just cover bare necessaries, and to be at peace in my own studio for the rest of my life.

Now it is definitely decided that I shall not go to Pont-Aven if I have to live in an hotel with these Englishmen and men of the *Ecole des Beaux Arts*, with whom one has to argue every evening—much ado about nothing!

This morning I was working at an orchard gay with plum-blossom, when suddenly there came a gust of wind and with it a peculiar effect which hitherto I had not observed in these parts, and which recurred from time to time. Now and again a shaft of sunlight would pierce the clouds and set all the little white blooms aglow—it was too beautiful for words! My friend the Dane joined me, and, at the risk of seeing all my paraphernalia fall to the ground at every gust of wind, I continued to paint. In this white light, there

is a good deal of yellow, blue and mauve; the sky is white and blue. But what will people say of the execution when one works in the open air in this way? Afterwards I thoroughly regretted not having ordered my colours at dear old Tanguy's; not that I should have gained anything, but he is such a comical little body! I often think of him. Do not forget to remember me to him when you see him, and tell him that if he would like some pictures for his shop-window, he can have some—and of the best.

Oh dear! It seems ever more and more clear to me that mankind is the root of all life. And even if the feeling that one has no share in real life remains a melancholy one (for it would surely be preferable to deal with living flesh and blood than with colour and clay, and one would sooner beget children than work at art or at the commerce of art), one feels notwithstanding that one does at least live, for among one's friends are there not numbers who also have no share in real life? We should try to do the same with business matters as with the human heart—that is to say, acquire or revive friendships{U}. As we no longer have anything to fear in regard to the ultimate fate of Impressionism, and as our victory is assured, we should behave decently and settle everything with calmness.

I cannot help thinking of Marat as the equivalent of Xanthippe in a moral sense (even though he be more powerful). That woman with the embittered heart remains, in spite of all, a stirring figure.

You were right to order from the colourman's the geranium lake which I have just received. All the colours that Impressionism has brought into fashion, are rather prone to lose some of their strength. That is why they should be laid on boldly and glaringly; for time will be sure to deaden them more than necessary.

Not one of the colours I have ordered: three chromes (deep, medium and pale), Prussian blue, veridian, emerald green etc.{V} is to be found on the palettes of the Dutch painters Maris, Mauve and Israels. On the other hand they were on Delacroix' palette, as he had a passion for the most prohibited colours—lemon yellow and Prussian blue; and with very good reason, for to my mind he created really magnificent things with this lemon yellow and blue.

Now I must tell you that I am working at two pictures of which I wished to make copies. The pink peach tree gives me most trouble.

You observe, from the four squares on the back, that the three orchards are more or less related. I am now painting an upright of a small

pear-tree, which will be flanked by two landscape-shaped canvases.[29] Altogether, then, that will make six pictures of orchards in blossom, and I hope that there will be three more to come, also related to each other in character. I should like to paint this series of nine pictures together. There is nothing to prevent us from regarding the nine pictures of this year, as the first rough plan of a final and much larger scheme of decoration which will have to be carried out at the same time next year, according to exactly the same themes.

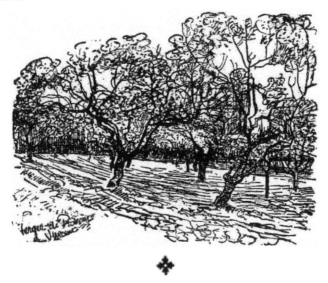

My drawings are done with a reed which is cut after the manner of a goose quill. I am thinking of doing a series of them, and hope the others will be better than the first two. That is my method. I had already tried it in Holland; but there I had not such good reeds as I have here.

Do you remember, just before my departure, our speaking about the Universal Exhibition and the fact that, in connection with it, Bouguereau, Lefèbvre, Benjamin Constant and the whole set intended going to Boussod's to make a complaint and to insist upon the firm B.'s (the first in the world) unflinchingly adhering to the principles of the highest and only desirable art (naturally their own art). And the upshot of it is, that we must be very careful; for it would be more than sad if you were to quarrel with these gentlemen. When one is released after having spent a long time in prison, there are moments in which one yearns for the walls of one's cell again, simply because one is no longer quite at home in a state of freedom—probably so called owing to the fact that the exhausting hunt after daily bread does not leave one a moment of liberty.

But you yourself know all this as well as I do, and you will have to forsake a good many things in order to attain to others.

Is it not true that Daumier is hung in the Beaux-Arts and Gavarni as well? Bravo to Daumier, but by no means to the Beaux-Arts!

I grow ever more and more doubtful about the legend concerning Monticelli, who is said to have drunk such great quantities of absinthe. With his life-work before one, it seems to me impossible that a man enervated by drink could possibly have produced such work.

In a day or two you will receive a call from the Danish painter who has been staying here. He wishes to see the Salon and then to go back home, perhaps with the view of coming South again next year. His three last studies were better and more full of colour than anything he has done hitherto. I do not know whether he will ever do anything great, but he is a nice fellow, and I am sorry he is going. I told him that a Dutch painter is staying with you, and if K. would only conduct him up to the Butte Montmartre, he would probably make a few studies. I have told him a good deal about the Impressionists, all of whom he knew by name, and he was also acquainted with some of their pictures. The question interested him immensely. He has a letter of introduction to R. He recovered his health here and now feels uncommonly well. It will last for two years, and then he will be wise to come back here for the same reasons of health.

What is the new book like, about Daumier, the Artist and his Work?

According to what you say, I hope that I will shortly come to Paris. In the circumstances which you have mentioned, it would be a real stroke of luck, now that everything is going to the dogs, and they are not doing well.

Possibly it would be easier to bring a few picture-dealers and amateurs to an understanding with the object of buying impressionist pictures, than to get the painters to divide among themselves the proceeds of the pictures sold. And yet the artists could not do better than to stick together, hand their pictures over to the association and share the proceeds of the sales, if only for the reason that the society guarantees the means of work and existence to its members. Degas, Claude Monet, Renoir, Sisley, C. Pissaro should take the initiative and say: Each of us five will give ten pictures (or better still, each of us will contribute works to the value of 10,000 francs, which value must be decided by experts—for instance, by T. and you— whom the society would appoint. And these experts would also have to invest in pictures). In addition to that we undertake to make a yearly

contribution to the value of so much. And we invite you all, Seurat, Gauguin and Guillaumin to join us, and the value of your pictures will be assessed by the same jury.

By this means the great Impressionists of the Grand Boulevard would preserve their prestige, and the others would not be able to reproach them with enjoying alone the advantages of a reputation for which there can be no doubt they are indebted, in the first place, to their personal efforts and their individual genius—but which in the second place is also increased, consolidated and maintained by a regiment of artists who up to the present have been in constant straits for money. It is only to be hoped that something will come of it all, and that T. and you will be chosen as experts (together with Portier perhaps). You, too, must surely be of the opinion that if T. and you join together you could persuade both Boussod and Valadon to grant credit for the necessary purchases. But the matter is pressing, otherwise other dealers will cut the grass from under your feet.

There are several themes here which have exactly the same character as in Holland: the only difference lies in the colour. Everywhere a cadmium yellow, produced by the burning sun, and in addition a green and blue of such extraordinary intensity! I must say that the few landscapes by Cézanne which I happen to have seen, give an excellent idea of it; but it is a pity I have not seen more of them.

I think you are quite right to take the "Books" to the "Indépendents" also; you ought to call this study "Paris' Novels."

I should be so glad if you could succeed in convincing T.! But only have patience! Every day I think of this artists' union, and the plan has developed further in my mind; but T. ought really to belong to it, and much depends upon that. For the moment the artists might possibly be convinced by us; but we can proceed no further without T.'s help. Without him we should have to listen to every one's complaint from morning till night; and then every member would come singly to ask for explanations concerning the rules {W}.

I think that, on the whole, I live like a workman here and not like an effeminate foreigner who is travelling for pleasure; and I should show no strength of will at all if I allowed myself to be taken advantage of as he does. I am beginning to set up a studio which will be able to serve the purpose of local painters or of friends who come this way.

I believe that you will soon make a friend of my Dane. It is true that he has not yet done anything good; but he is clever and his heart is in the right place, and he has probably begun to paint only quite recently. Do please avail yourself of a Sunday to make his acquaintance.

Do you know G.'s expression when he compresses his lips and says "no women?" That would make a fine Degas head. It cannot, however, be gainsaid; for to spend one's whole day at mental work, reckoning and meditating and thinking over business, is in itself enough for the nerves.

In the midst of an artistic life there arises again and again the yearning for *real* life, which remains an unrealizable ideal. And often enough the desire to devote one's self completely to art, with ever fresher strength, entirely disappears. One feels exactly like an old cab horse, and one knows that one must always return to the same old shafts when all the while one would so love to live in the fields, in the sun, near the river, in the country, with other horses, also free, and have the right to procreate one's kind. And I should not be at all surprised if this were whence the heart trouble comes. One offers no resistance, neither does one resign one's self; the fact is, one is ill; the thing will not go away of its own accord, and yet there is no remedy for it. I really do not know who called the state "a case of death and immortality."

In the cart one draws must be useful to people whom one does not know. If we believe in the new art, and in the artists of the future, our presentiment does not deceive us. Shortly before his death good old father Corot said: "Last night in my dream I saw landscapes with pink-coloured skies." And, as a matter of fact, are not pink and even yellow and green skies to be found among impressionist landscapes? This is only to show how many things of whose coming one has a presentiment, actually do come to pass in the future. We do not, however, yet stand on the edge of the grave, and we feel that art is greater and longer than our lives. We do not feel moribund, but of little account; and in order to be a link in the chain of artists we pay a heavy price in youth, health, and freedom. And we no more enjoy the latter than the poor cab-horse does, that has to convey people, who wish to enjoy the spring, out into the open country. That hope of Puvis de Chavannes' should and must be realized: there is an art of the future, and it must be so beautiful and so young that even if we now

sacrifice our own youth to it, we must make up our loss in the joy of living and in peace. {X}

<p style="text-align:center">❖</p>

I do not see the future black, but full of difficulties, and often I ask myself whether these will not prove stronger than I. This thought occurs chiefly in times of physical weakness, as for instance, during the week when I suffered so infernally with toothache that I was forced to waste time. Nevertheless I have just dispatched a roll of small pen-and-ink-drawings to you—I think about a dozen—and from these you will be able to see that even if I have ceased from painting, I have not given up work. Among them you will find a rapid sketch on yellow paper; a stretch of grass on the open space at the entrance of the town, and in the background a house, of which I have rented the right wing (four rooms, or rather two rooms and two little closets). The house is painted yellow outside and whitewashed within. It stands right in the sun and I have taken it at a rental of fifteen francs a month.

<p style="text-align:center">❖</p>

If our hopes do not prove false—which I am convinced they will not—and the impressionist pictures rise in price, we ought to paint a large number and avoid selling them too cheaply. This is one more reason for being careful of the quality and for losing no time. Then in a few years I see the possibility of holding the disbursed capital, if not in money, in any case in treasure, in our own hands.

<p style="text-align:center">❖</p>

I am convinced that in this place nature seems to have been made for the very purpose of being painted chromatically, and that is why the chances of my ever being led away from the spot, grow fewer every day.

<p style="text-align:center">❖</p>

Raffaëlli has painted Edmond de Goncourt's portrait; it must be very beautiful, is it not?

<p style="text-align:center">❖</p>

The studio is in such a prominent position here that I do not think my establishment is likely to attract any female; and an affair with a petticoat might too easily lead to a binding relationship. Moreover, it seems to me as if the morality here were far more human and natural than in Paris. But with my temperament it would be impossible to lead a loose life and to work as well, and circumstances being as they are, one must be content to

paint pictures, which is by no means real happiness or real life. But, after all, even the artistic life, though we know it is artificial, seems to me so vigorous and vital, that we should be ungrateful not to be satisfied with it.

✤

I shall hang a few Japanese knick-knacks on my walls.

✤

At Claude Monet's you will see some beautiful things, and what I am sending you will appear bad beside them. I am dissatisfied with myself and with my work; but I see the possibility of doing better in the future. Later on, I hope that other artists will appear in this beautiful land, who will create an art like that which the Japanese have created in their own country; and to pave the way to this is not so bad after all.

I feel certain that I shall always love the scenery of this place. It is like Japanese art, once it has found a place in one's heart one can never cast it out.{Y}

✤

The other day I received a visit from M. K., R.'s friend, who, by the by, came back last Sunday. I must really call on him one day, and look at his work; for I have not yet seen anything he has done. He is a Yankee who probably does better work than most of his countrymen; but in spite of it all—a Yankee! Does that not cover everything? I shall be able to judge of his capacities only when I have seen his pictures and drawings.

✤

It seems to me as if Messrs. B. and V. cared nothing for the good opinion of artists. But, to be quite open, I thought the news was bad, and I could not help breaking into a cold sweat on hearing of it. I have been thinking about it ever since; for this conversation with the said gentlemen is to a certain extent a symptom of the fact that Impressionism has not taken deep enough root.

As for me, I immediately stopped painting pictures, and continued work upon a series of pen-drawings; for, I said to myself, a breach with these gentlemen might make a reduction in my expenses a desirable thing from your point of view. I am not so very much attached to my pictures, and will drop them without a murmur; for, luckily, I do not belong to those who, in the matter of works of art, can appreciate only pictures. As I believe, on the contrary, that a work of art may be produced at much less expense, I have begun a series of pen-drawings.

The people here take too much advantage of the fact that with my canvases I need a little more room than other customers, who do not happen to be painters, and they improve the occasion by extorting exorbitant payments from me.... It is always a nuisance to have to cart all one's materials and pictures about with one, and it considerably impedes one's movements.

Very often I am obsessed by the discomfiting feeling that we are both being duped by Messrs. B. V. and Co. But I try to quell this feeling.{Z} Above all, do not let them make you their dupe.... This is enough for to-day.

Do you know what I think, on the whole, of the women of Arles, and of their much vaunted beauty? They are certainly very attractive; but they are surely no longer what they must have been. And as their race is degenerating they are now much more like a Mignard than a Mantegna. Nevertheless they are beautiful (I here refer only to the Roman type, which is somewhat monotonous and trivial) and by way of exception there are women like those whom Renoir and Fragonard paint, and some who cannot be classified according to any school of painting of the past. Taking all these facts into consideration the best thing to do here would be to paint portraits of women and children. But—I do not feel that this is my allotted task—I am not enough of a "Bel-Ami" for the work. But I should be mightily glad if this Bel-Ami of the South (Monticelli was not the man, although he prepared the way for him, and I feel that he is in the air, even if I myself am not the man)—I should be mightily glad, I say, if an artist could be born among painters, such as Guy de Maupassant was among writers, who could joyfully paint the beautiful people and things which are to be found here. As for me, I shall go on working, and now and again I shall paint something lasting. But who is going to paint men as Claude Monet painted landscapes? Be this as it may, you must feel the same as I do about it—it is in the air.

Rodin? He is no colourist. He is not the painter of the future. For the painter of the future will have to be a colourist such as has never yet been seen. Manet prepared the way for him; but you know that the Impressionists have already shown themselves even stronger than Manet in their colour. I cannot imagine this painter of the future leading the life I lead. He would not have to go to small restaurants, wear false teeth and visit

third-rate cafés frequented by Zouaves.{AA} But I have a feeling that all this will come in a later generation. And we must do all we possibly can to promote its advent, without doubting or flinching.

I have just read Zola's "Au Bonheur des Dames" again; and it seems to me more beautiful every time.

I am writing to you again to-day, because, when I wanted to pay my bill at my hotel, I again discovered that I had been robbed. I suggested an arrangement which, however, has not been accepted, and when I wished to remove my things they refused to allow me to do so. "Very' well," I said, "we shall discuss the matter before the Justice of the Peace" (where I shall probably be declared in the wrong). Now I must retain enough money to be able to pay in the event of my being held to be wrong—67·40 francs instead of 40 francs, which is the sum I owe. A thing that often makes me feel sad is that living is dearer here than I had reckoned, and that I cannot manage to subsist on the same amount as our friends in Brittany. But now that I am feeling better I refuse to think that I am defeated. After all, you have not yet seen any of my work here, and I have already spent a good deal of money. I am therefore sending you a case containing all the work I have done, with the exception of one or two studies which I had to destroy. I have not signed them all; a dozen of them are off their stretchers, and fourteen of them are still stretched. One is a little landscape with a white, red and green cottage, and a cypress. You have the drawing of that one, and I painted it all in my studio. It will show you that if you like I can paint you small pictures, after the manner of crape prints,[30] from all my drawings.

Meanwhile I must pay my hotel bill, but there is a note upon it to the effect that the payment is being made only in order that I may recover possession of my things, and that the exorbitant charges will be laid before the Justice of the Peace. But with all this I have scarcely a halfpenny left. It is very annoying, for this business interferes considerably with my work, and it is very beautiful out of doors just now.

Strangers are bled in these parts; on the other hand the natives are quite justified in regarding them as fair game and in extorting as much as possible from them. But it is discouraging to work hard and to see how the money pours into the pockets of people one abhors. But we must put a stop to it. I am going to set up a studio here which is to be more than a temporary affair, and in which, if necessary, I shall be able to accommodate another painter. It is cheaper to live right in the heart of the country, like M. K., but he is exceedingly lonely, and up to the present has done very little

work. In that case it is better to work hard and to pay more, if there is no other way out of it.

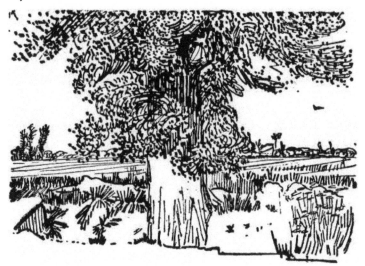

If you will lay aside the best pictures in the batch I have sent you and regard them as in part payment of my debt to you, on the day when I shall have sent you 10,000 francs in pictures, I shall feel much more at ease. The money already spent during former years must return our way, at least in the form of articles of value. It is true that I am still very far from having achieved all that is necessary; but I feel that in the midst of the beautiful scenery here, everything is at hand to make me do good work. It will only be my fault, therefore, if I do not succeed. You once told me that in the space of one month Mauve had painted and sold 6000 francs' worth of water-colours. So such strokes of luck are possible, and in spite of all my monetary troubles I do not see why they should not happen to me.

In the batch I am sending you there are the "Pink' Orchard," painted on coarse canvas, the "White' Orchard" (landscape shape);[31] and the "Bridge." I am of opinion that these pictures will rise in value later on. And fifty or so pictures like these would compensate us for the small amount of luck we have had hitherto. Take these three pictures for your collection and do not sell them; for later on each one of them will certainly fetch 500 francs. I shall begin to breathe freely only when we have collected fifty such pictures.

Just a few lines to tell you that I have called upon the gentleman whom the Jew in "Tartarin" called the "Zouge' de paix." I have, at least, saved twelve francs, and my landlord was reprimanded for having detained

my box despite the fact that I had not refused to pay. It would have been very disastrous for me if the other party had won his case, for he would certainly have told everybody that I could not, or would not, pay, and that he was compelled to detain my box. As it was, however, when we were walking out of the place together, he said to me that the whole thing had happened in a moment of anger, and that he had no intention of offending me. Of course this was precisely what his object had been, for he had probably seen that I had had enough of his place and did not wish under any circumstances to remain a day longer in it. In order to obtain the reduction which was actually due to me I ought probably to have claimed very much more. You can well understand that if I were to allow anybody and everybody to do as they pleased with me, I should soon be robbed of my last farthing. {BB}

TO E. BERNARD.

MY brother wrote to me the other day saying that you intended coming here to have a look at my pictures. From this I gather that you are back, and I am very glad that you should have thought of coming down here to see what I have done. I, for my part, am very keen to see what you have brought back from Pont-Aven. My head is not in a fit state for writing, but I feel so out of it because I have not the least idea what you, Gauguin and the others are doing. I must, however, be patient. I still have about a dozen studies here, which are possibly more to your taste than the others painted in the summer, which my brother must have shown you. Among these studies there is one of an entrance to a quarry: light mauve-coloured rocks on a ruddy soil, such as one very often sees in Japanese drawings. In regard to the drawing and the division of the colours over large surfaces, it bears some relation to your things from Pont-Aven. In these last pictures I show more self-mastery, because while painting I felt much stronger. For instance, there is a canvas about 36 in. by 27½ in. among them of a ploughed field painted in a broken mauve tone, with a background of hills which reach right up to the edge of the frame. Thus it contains nothing save rough ground and rocks with a thistle and dry grasses in one corner; by way of a figure there is a little violet and yellow man. I trust that this will prove to you that I am not yet effete.

Heavens! what a miserable little stretch of country this is! It is all very difficult to render, especially if one wishes to bring out its intimate character, and make it not merely approximately right, but the genuine soil of La Provence. To accomplish this one must work hard, for the qualities to be seized are naturally a little abstract. It is a matter, for instance, of giving the sun and the sky their proper strength, and the scorched and melancholy soil its glow and its subtle scent of thyme.

The olive trees here are really just what you would like. I have not been lucky with them this year; but I have quite resolved to tackle them again. They are fine silver on orange-coloured or violet-blue ground, beneath the broad blue heavens. I have seen olive trees by certain painters, and by myself as well, which do not give this effect at all. This silver grey is pure Corot, and what is still more important, it has not been painted yet; whereas various artists have already been successful with apple-trees and willows. There are also relatively few pictures of vineyards, which are

nevertheless so variegated in their beauty. There is quite enough here to keep me busy.

By-the-bye, there is something which I am very sorry not to have seen at the exhibition—a series of dwellings from all lands, organized I believe by Garnier. Do you think you could give me an idea, or better still, a coloured sketch of a primitive Egyptian house, for you surely must have seen the exhibition. It must be quite simple: a rectangular block on a sort of terrace; but I would give anything to know the colour. I read in a certain article that it was blue, red, and yellow. Did you notice this? Please do not forget to give me details about it.... I for my part know nothing more delightful in the way of architecture than the peasant's cottage, with its moss-clad thatched roof and its smoke-blackened hearth. As you see, I am very exacting. In an illustrated work I saw a sketch of some old Mexican houses which also seemed to me very primitive and beautiful. Oh, if one could only know all about those times, and could paint the people that lived in those houses, the result might be pictures as beautiful as Millet's. After all, everything we really know for certain, at present, is to be found in Millet, not perhaps in the colour, but in the character, in the content—that is to say, in something which is animated by a strong faith....

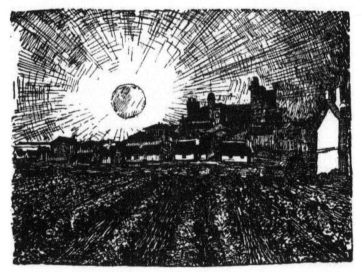

I trust you will have another look at my pictures when I send my autumn studies in November; if possible, let me know what you have brought with you from Brittany; for I am anxious to know which of your works you yourself think the most highly of. And then I shall quickly reply.

I am at work on a big picture, a quarry. As a matter of fact it is exactly the same theme as that study which I have of yours with the yellow tree. It

represents the lower portions of two mighty rocks, with a little spring of water running between them, and in the background there is a third mass of rock which closes in the quarry. Such themes are seductively melancholy, and it is so amusing to paint in thoroughly wild scenes where one has to fix one's easel deep down in the stones to prevent the wind from blowing everything over.

1890.

When Gauguin was at Arles I allowed myself, as you know, to be led into working from imagination, and I painted a woman in black reading a novel. At that time I thought that working from imagination was very delightful. But, my dear friend, it is an enchanted land, and suddenly one finds oneself confronted with an insurmountable wall. Maybe after a life spent in manly effort and endeavour, and after a hard struggle shoulder to shoulder with nature, one might venture to try it; but for the present I shall not crack my brains over it, and I have slaved all the year round painting from nature, and thinking neither of impressionism nor anything else. And yet, in spite of it all, I let myself go again, but it only resulted in another failure, and I have had enough of it. For the time being, therefore, I am working at the olive trees, and trying to seize the various effects of the gray sky over the yellow ground, together with the black and green note of the foliage, or of the deep violet ground and foliage against a yellow sky, or again, of the yellow-red ground against a pale green and pink sky. After all, these things interest me more than the abstractions referred to above. If I have not written for so long, it is because I had no wish to enter into any discussion, and scented a danger in all this reflection, inasmuch as I must guard against my illness and keep my head calm. By dint of quiet and steady work, the subjects will come of their own accord. The chief thing is to strengthen one's self entirely through reality, without any pre-conceived plan and without any watchword hailing from Paris. By-the-bye, I am very dissatisfied with this year's work; maybe, however, it will prove a sound foundation for what is to come. I have allowed myself to be completely saturated with the air of the hills and of the orchards; time will show what this has done for me. The whole of my ambition is at present concentrated upon a little handful of earth, sprouting corn, an olive garden, a cypress (the latter, by the way, not easy to paint).

Here is the description of a picture which now lies before me (a view in the park belonging to the Hospital for Nervous Diseases of which I am now an inmate): to the right, a grey terrace, a piece of wall and a few faded rose-trees, to the left the park ground (English red) the soil of which is scorched by the sun and covered with pine-needles. The edge of the park is

planted with tall pine-trees, the trunks and branches of which are English red, and the green of which is all the more vivid for having a touch of black. These trees stand out against the evening sky, the yellow ground of which is streaked with violet stripes. Higher up the yellow shades off into pink and then into green. A low wall, also English red, obstructs the view and is overtowered only at one spot by a little violet and yellow-ochre hill. The first tree has a gigantic trunk which has been struck and split by lightning; one side branch alone still projects high up into the air, and lets showers of dark green needles fall down. This gloomy giant—a vanquished hero—which one can regard as a living being, is a strange contrast to the pale smile of a belated rose that is fading away on a rose bush right opposite. Under the pines there are some lovely stone seats and dark box-trees. The sky produces yellow reflections—after a shower—in a pool of water. In a ray of sunshine—the last reflection—the dark yellow ochre is intensified to a glowing orange. Dark figures steal in and out between the tree trunks. You can well imagine that this combination of red ochre, of green bedimmed with grey, and of black lines, defining the forms, may help to call forth that feeling of fright which often seizes many of my fellow-sufferers. And the theme of the great tree struck by lightning, and the sickly smile of that last autumn bloom in green and pink, enhanced this effect. Another picture represents a sunrise over a field of young corn, the converging lines of the furrows rise in the picture as far as a wall and a row of mauve-coloured hills—the field is violet and yellow-green. The glaring white sun is encircled by a large yellow halo. In this picture, I tried, as a contrast to the other, to express repose and perfect peace. I have described these two pictures to you, in order to show you that one can give the impression of fear, without going direct to the historical Gethsemane, and that one can paint a comforting and gentle subject without depicting the chief actors in the Sermon on the Mount. It is unquestionably a good and proper thing to seek inspiration in the Bible, but modern reality has taken such possession of us that even if we try to divorce ourselves from it, in order to revive the old memory of former days, the incidents of our life tear us from such considerations, and our individual experiences again fill us with personal sensations of joy, vexation, suffering, anger or laughter. Heavens! the Bible! Millet was brought up on it entirely in his childhood, and read nothing else; and yet he never, or scarcely ever painted real Biblical subjects.

Corot painted Christ in an olive grove with the shepherds' star, and it was sublime; in his works one feels the spirit of Homer, Virgil, Aeschylus and Sophocles and often of the Gospels; but only discreetly suggested; for modern sensations, which are possible and common to us all, always preponderate. Even if painting be detestable and much too full of hardships nowadays, he who in spite of all chooses this craft must on that very

account be a man full of devotion and firmness. Society so often makes our life very hard indeed, and that is the cause of our shortcomings and of the imperfection of our work{CC}.... I suffer very much from having absolutely no models; but on the other hand there are some beautiful landscape subjects here.

Have you seen a study of mine of a small reaper, a yellow cornfield and a golden sun? Although I did not solve it, I at least attacked the infernal question of yellow in this picture. I speak of the study painted in impasto, which I did direct from nature, not from the copy, which is painted in diagonal brush-strokes and in which the effect is very much weakened. I wanted to paint it in pure cadmium{DD}.

MORE LETTERS TO HIS BROTHER

DURING the journey I thought just as often of you as of the new country through which I was travelling, and I said to myself, that later on you would perhaps come here frequently. It seems to me almost impossible to work in Paris, if one has not got at least a haven of refuge, where one can rest and recover one's calm and one's self-reliance. Otherwise one must become quite stupefied.

Before I reached Tarascon I saw a beautiful landscape: mighty yellow rocks with remarkably complicated lines and imposing forms; in the narrow coves between them there were a number of small round trees standing in rows, and to judge from their grey-green foliage they must have been lemon trees.

Here in Arles the ground is a magnificent red colour and is planted with vineyards. The background of the hills is of a delicate mauve, and many a stretch of the country lying under the snow, together with the white peaks, against a sky as luminous as the snow itself, looked like the winter landscape of the Japanese.

For the present I do not find living as inexpensive here as I hoped it would be; but—I have finished three studies—a feat which would probably have been impossible in Paris just now.

As for the Impressionists, I should think it right and proper if they were introduced into England if not directly through you, at least through your agent.

It seems to me as if my blood were beginning to circulate a little more actively. As this was not the case during the latter part of my time in Paris, I literally could not hold out any longer.

I was hoping to be able to paint a beautiful blue, and I do not yet despair of doing so; for in Marseilles one ought surely to be able to obtain the raw materials first hand. I should like to procure the sort of blue that Ziem paints, which is stronger and more decided than that of other painters.

The studies I now have are: "An Old Woman of Arles," "A Snow Landscape," "A Piece of the Street with a Pork-Butcher's Shop." The women here are really beautiful. I say this in all sincerity. On the other hand, the Arles Museum is appalling, and it is such a piece of humbug that it would be much more at home in Tarascon. I have also seen a museum of antiquities—the latter were genuine.

The draft of your letter to T. is perfect. I trust that in copying it you did not water it down too much. It seems to me that your letter to T. completes the one I wrote; as I was very much annoyed at having sent it in that form. For you must have observed that the idea of inducing T. to take the initiative in introducing the Impressionists into England occurred to me only while writing, so that I was only able to refer to it inadequately in a postscript. Whereas in your letter you discuss the question more in detail.

As to the Exhibition of the "Indépendents," I leave you an absolutely free hand. What do you say to exhibiting the two great landscapes of the Butte Montmartre? I am more or less indifferent about it; I am relying more upon this year's work.

Here it is freezing hard and the ground is continually under snow. I have painted a study of the snow-covered ground with the town in the background. I have also made two small studies of a branch of an almond tree, which, despite the wintry weather, is already blossoming.

At last, after all this time, the weather has changed. This morning early it became quite mild. I have thus had the opportunity of making the acquaintance of the Mistral. I have already taken several walks in the neighbourhood; but the wind was so strong on each occasion that it was impossible to paint. The sky was a vivid blue and the great sun shed such powerful rays that it melted almost all the snow away. But the wind was so dry and piercing that it made me have goose-skin all over. However, I saw some beautiful things; the ruin of an abbey on a hill, covered with holly, pines and gray olive trees. I hope to be able to tackle this very shortly.

For Gauguin—as for many of us, and certainly for ourselves—the future presents many great difficulties. I firmly believe that we shall triumph in the end; but will the artists themselves ever be able to taste of that triumph and enjoy happier days? Has T. written to you? In any case, believe me, your letter will do good. Even if he does not answer, he will at least hear about us, etc.

Poor Gauguin is unfortunate; I am afraid that convalescence in his case will last longer than the fortnight he has had to spend in bed. When shall we see a generation of artists with healthy bodies? At times I feel really

wild with myself; for, after all, it is no good being either more sick or more sound than the others; the ideal thing would be to have a temperament strong enough to reach the age of eighty and to have healthy blood withal. Still without all this one would be consoled if only one were sure that a more happily constituted generation of artists was going to follow the present one.

I see that you have not yet had an answer from T. I do not think it necessary that we should petition him further by another letter. All the same, in the event of your having to discuss any matter of business with him, you might let him feel in a postscript that you are surprised he has not let you know whether or not he has received the letter in question.

To refer to my work once more: to-day I painted a picture on a canvas about 25½ in. by 19 in.[32] It represents a drawbridge across which a small cart is being drawn, that stands out distinctly against the blue sky. The river is also blue, the banks are orange, and there is much green vegetation about them. A group of washerwomen are standing on the bank with corsets and caps of many colours. I have also painted another landscape with a small rustic bridge and some more washerwomen, and in addition to this, a grove of plane-trees close to the station. Since I have been here I have painted, in all, twelve studies.

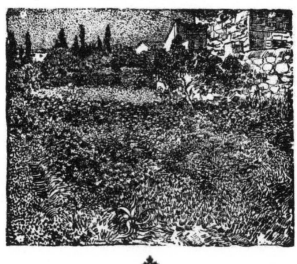

Do you know, dear brother, I feel just as if I were living in Japan. I will say no more. And this notwithstanding the fact that I have not yet seen anything in its accustomed glory. And even if I feel sad about the expenses

being so heavy and the pictures not being any good, I do not despair, for I am certain that my long sojourn in the south will be successful. Here I see and learn many new things, and if I am gentle with my body, it will not play me a bad turn. For many reasons I wish to found a home of refuge here, which in case of complete exhaustion might serve the purpose of putting one or two poor Paris cab-horses like yourself and many of our friends among the Impressionists, out to grass.

I painted my last three studies with the help of a view-finder divided into squares{EE}, which, as you know, I often use. I attach some importance to it, because I do not think it unlikely that, sooner or later, more artists will make use of it, just as the old German, Italian, and, I believe, the Flemish painters did. The modern way of using it may differ slightly from the old way; but is it not exactly the same with oil-painting? To-day absolutely different effects are aimed at from those which were sought by J. and H. van Eyck, the inventors of technique. This is to show you that I hope always to work independently and for myself alone. I believe in the absolute necessity of a new art of colour and drawing, as also of the whole of artistic life. And if we work with this strong faith, we may hope that it will not prove to be an illusion.

But what are we hearing from T.? Nothing at all? If I were you I would write him a few short lines, couched in sober language, in order to express your surprise at not having received an answer from him. I say this more particularly for you; for even if he does not reply to me, he must to you. And you must press him to do so, otherwise you would lose your prestige, and this excellent opportunity ought really to be seized.... What you must particularly avoid is to allow yourself to be treated like a dead man or a pariah.

I have received a few lines from G., who complains about the bad weather. He is still unwell, and says that of all the vicissitudes of life, none is more harassing to him than straits for money. And yet he feels that he is to be cursed with this condition for ever.

We have had rain and wind every day of late. I have been working at home upon the study of which I made a sketch in my last letter to Bernard. I have tried to make the colours like that of stained glass windows, and the drawing direct and firm.

I am just reading Guy de Maupassant's "Pierre' et Jean." It is very fine. Have you read the preface to it, in which he declares the artist free to exaggerate and to create a more beautiful, more simple, and more comforting life in the novel, and explaining what Flaubert wished to express

with the words, "talent is a long trial of patience," and originality an act of will-power and of most intense observation?

There is a porch here—that of St. Trophime—which I am beginning to think extremely beautiful. It is, however, so cruel, so monstrous, and so like a terrifying and grotesque spectre of dreamland, that, beautiful monument though it is, and great as is its style, it seems to me to be part of another world, to which I am just as pleased not to belong as I am not to have lived in the glorious world of Nero.

Shall I admit the truth, and add that the Zouaves, the houses of ill-fame, the charming little girls of Arles who go to their confirmation, the priests in their surplices, in which they look like dangerous antediluvian animals, {FF} and the drinkers of absinthe also seem to me like creatures from another world? All this does not mean that I should feel more at my ease in an artistic world, but simply that I prefer to laugh about it than to feel isolated; because I have the idea that I should be sad if I could not look at everything in a humorous light.

In the evenings I have company; for the young Danish painter who is here is a very nice fellow. His pictures are dry, correct, and sober; but in my opinion this is not a serious fault, provided that the artist be young and intelligent. He began by studying medicine; knows Zola's, Goncourt's, and Guy de Maupassant's works, and has enough money to lead a pleasant life. In addition to this he is animated by the earnest desire one day to do better work than he is now doing. I believe he would do well to postpone his return to his Fatherland for a year, or to return here after only a short visit to his home.

One of these days we must certainly try to find out how the case stands with this Mr. T. In the interests of our friends he ought really to say something definite. It seems to me that we are all to some extent bound to see that we are not looked upon as dead. It is not our cause alone that is at stake, but the common cause of all Impressionists. Consequently, as he has been appealed to by us, he owes us a reply. You will agree with me that we cannot make any progress before we receive a categorical statement of his intentions. If we consider that a permanent exhibition of impressionist work in London and Marseilles is a desirable thing it is obvious that we shall strain every nerve to bring it about. Now the question is, will T. come in with us or not?... And has he reckoned, as we have done, on a possible depression of the market in pictures which now stand at high prices, a depression which, in my opinion, will very probably occur the moment the

prices of impressionist pictures begin to rise. You must perceive that the purchasers of expensive pictures will only achieve their own ruin by opposing the triumphal progress of a school which, owing to its energy and perseverance, has for years shown itself worthy of a Millet or a Daubigny, etc.

I congratulate you heartily on your letter from T. I think it entirely satisfactory. I am convinced that his silence concerning me was not intended as a slight. Besides, he must have taken it for granted that you would let me read his reply.

Moreover, it is much more practical for him to write to you; and as for me, you will see that, provided he does not think too poorly of my work, he will write to me soon enough when he has seen it. I can only repeat that I am more pleased about his simple and kindly letter than I can tell you. You will have noticed that he says he wants to purchase a good Monticelli for his own collection. What do you say to telling him that in our collection we possess a picture of a bunch of flowers which is more artistic and more beautiful than a bouquet by Diaz; that Monticelli often painted a bouquet of flowers, in order to be able to unite the whole scale of his richest and most harmonious colours in one picture, and that one would need to go back to Delacroix to find a similar wealth and play of colours; that—and I am now thinking of the picture which is at the Delarbeyrettes—we know of another bouquet picture, excellent in quality and moderate in price, which we consider, in any case, far more valuable than his figure pictures, which are to be found for sale at every corner, and which belong to the period when Monticelli's talent was declining. I hope you are sending him G's lovely seascape. Heavens! how glad I am that T. has answered in this way!

I have just painted a group of blossoming apricot trees in a small fresh-green orchard. I really had a good deal of trouble with the picture of the sunset, the figures and the bridge, about which I wrote to Bernard. The bad weather prevented me from finishing the picture on the spot, and when I tried to finish it at home I completely spoilt the study. I immediately started painting the same subject again on another canvas; but the weather had changed completely, and all the tones were grey.

Many thanks for all the steps you have taken with the "Indépendents," but—although it does not matter at all this time—in future please print my name in the catalogue just as I sign it on my pictures, i.e., Vincent, and not van Gogh; and this for the simple reason that in this country no one can pronounce our surname. Enclosed I return you T.'s and R.'s letters; perhaps it would be interesting to keep the correspondence of the artists for some future time. It would not be a bad plan to include B.'s

small head of the Brittany girl in your next parcel. One ought to show that all Impressionists are good and that their work shows versatility.

✦

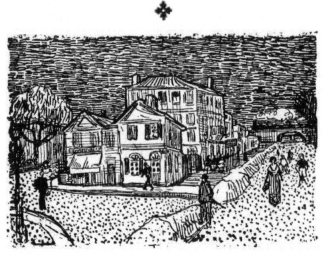

Would you like me to go to America with you? It would only be natural for the gentlemen to defray my travelling expenses. I could be indifferent to a good deal, but not to all things! And among the things about which I am not indifferent is, above all, your health, which you must recover completely. Now I believe that you ought to seek more refreshment than you do from Nature and from artists. And I would prefer to see you independent of Goupil's and established on your own account with the Impressionists, rather than that you should adopt this alternative and be constantly travelling with valuable pictures belonging to the gentlemen in question. When our uncle was the partner, he made them pay him very well for many years; but see what it cost him! Yes, yes, your lungs are good, but ... just try a year at looking after yourself properly, and then you will realize the danger of your present life. You now have ten years of life in Paris behind you. That is more than enough. To this you will probably reply that Détaille, for instance, has perhaps thirty years of Paris life behind him, and that he is as straight as a die. Very well, do as he has done, if your constitution is anything like his; for in our family we are very tough. All I should like to say may be summed up as follows: If these gentlemen want you to do their dirty work for them, and at such a great distance too, then either demand a high price for the work, or else decline it and devote yourself entirely to the Impressionists. For even if you do less business with their work and turn over less money, you will at least be able to spend more of your time with nature. My health is decidedly improving and my digestion has been getting much better during this last month. I often suffer

from unaccountable and involuntary fits of excitement or of apathy; but they pass away when my nerves grow calm again.

I constantly reproach myself with the fact that my painting does not bring in as much as it costs, and yet one must work. You must, however, remember that if ever it should become necessary for me to go into business, in order that your lot may be lighter, I should do so without regret.

It is strange; on one of my last evenings in Mont-Majour I saw a red sunset; the trunks and needles of pines which were growing on a mass of rock, were vividly illuminated. The rays of the sun bathed the trunks and the needles in a fiery orange-yellow light, while the other pines in the background formed a mass of Prussian blue against a pale blue-green sky. That is surely precisely the same effect as that picture of Claude Monet's of which you spoke to me. It was simply glorious. The white sand and the layers of white rock beneath the trees were bluish in colour. How glad I should be to paint the panorama of which you have the first drawings. Its expanse is so vast! And it does not get grey in the background, but remains green to the farthermost line.

You must understand that I would prefer to drop my art than to think that you were slaving your life out to earn money. It is certainly necessary; but are we so situated that we must go to all these pains to get it? If you realize so well that to prepare for death (a "Christian idea" which in my opinion Christ fortunately did not share at all—he who according to the view of such people as considered him crazy, loved men and things on earth not wisely—but too well); if then, I say, you realize so well that to prepare for death is a thing one would prefer to leave severely alone, do you not also see that self-denial, and sacrifice for others is an error too, especially if it is as good as suicide, for in that case one turns one's friends into murderers. If things have come to such a pass that you have to travel about in this way without being able to take a rest, I really feel as if I no longer had any desire ever to be quiet again. And if you accept these proposals, well and good; but in that case make a stipulation with these Goupils that they should take me back into their employ as soon as they can, and that they should let me join you on these journeys. Men are more important than things, and the more I worry myself about pictures, the colder they leave me. My reason for trying to paint them is that I would fain be reckoned among the artists.

I have painted a canvas in the open, in an orchard. The ground was ploughed and mauve in colour, there was a fence of reeds and two pink peach trees against a bright blue and white sky. Perhaps it was the best landscape I have ever painted. The very moment I had brought it home, our sister sent a Dutch essay to me in memory of Mauve (the portrait in it is very good—a fine etching—the text is bad). I do not myself know what moved me so profoundly and made my throat feel tight, but on my picture I wrote: "In memory of Mauve. Vincent and Theo." And if you also like it, send it as it is to Madame Mauve. I purposely selected the best study I have painted here; who knows what they will say about it at home; but we do not mind that. I had the feeling that something cheerful and delicate would be fitting in memory of Mauve, and not a heavy, serious study.

Ne crois pas que les morts soient morts,
Tant qu'il y aura des vivants
Les morts vivront, les morts vivront.

That is how I look upon it—no more sadly than that.

Now you must be more careful to keep in touch with T. Whether we are all successful or not, I am beginning to think that within a year or so, everything will be all right. It seems to me as if T. and not R. should found the Impressionists' exhibition in England.

You can tell G. quite frankly that my decided opinion is that in his own interests as well as in the interests of the firm, his prices were ludicrous. After all that has happened, R. must either pay handsomely or the artists must shut the door in his face. I have seen enough of that sort of thing already, and after mature consideration that is my opinion. With a price of 300 francs one spoils one's subsequent sales, and that is a thousand pities.

I am in a frenzy of work, for the trees are blossoming, and I wished to paint a Provence orchard in all its unbounded cheerfulness and beauty. To keep a clear head for writing in the midst of it all, is therefore no easy matter. Yesterday, for instance, I wrote some letters which I afterwards tore up. Every day I feel more strongly that we must do something in Holland, and it must be done with the utmost verve and with that French gaiety which is worthy of the cause for which we stand. This is therefore a plan of

campaign which will cost us the best pictures which we have produced together, pictures which are certainly worth a few thousand franc notes, or which have cost us, at least, something in money and a great deal in health and life. It would be a clear and sonorous reply to all the whispered suggestions that we are already half dead, and a revenge for your journey last year, and your cold reception, etc. But enough of this. Well, then, suppose we give Jet Mauve the picture in memory of Mauve, a study to Breitner (I happen to have got one which is like the study I exchanged with R. and Pissaro: oranges on a white ground, with a blue background) then a few studies to our sister, and to the Modern Museum at the Hague (as so many memories are connected with it) the two Montmartre landscapes which are at the Independants' exhibition. There still remains one other unpleasant thing. When T. wrote: "Send me impressionist pictures, but only those which you consider very good" you put one of my pictures among the batch. And now I am in the infernal position of having to convince T. that I am and will remain a real Impressionist of the *petit boulevard*. What do you say to my giving him a picture for his collection? Just lately I have been thinking things over, and have found something ever so much more amusing than my usual kind of study; it is a drawbridge, with a small yellow carriage upon it and a group of washerwomen. In this study the ground is a glaring orange, the grass is very green, and the sky and the water are blue. It must have a frame of royal blue and gold, the inside blue and outside a gilt moulding. The frame might be made of blue plush; but it would be better to paint the wood blue.... I cannot find time to write a quiet letter; my work absorbs me too much. But what I particularly wished to say to you is that I should like to paint a few studies for Holland, so as to have done with it. Quite recently, whilst thinking of Mauve, T., our mother and Will, I got more excited than was good for me, and I was comforted by the thought of painting a few pictures for home. After that I shall think no more about them, and think only of the *petit boulevard*.

I am once again in the midst of work and am still painting blossoming orchards.

The air here is decidedly good for me, I only wish you could fill your lungs full of it. One of its effects is very strange; a small glass of cognac makes one drunk here. But as I do not feel the need of such stimulants in these parts to keep my blood circulating, my constitution will not suffer so much.

I hope to be able to make real progress this year; for I sorely need to do so.

I have a new orchard which is just as good as the pink peach trees. It is an orchard of apricot trees, most delicately pink in colour. At present I am working at some plum-trees with yellow-white blossom and a maze of black branches.

I am using an enormous amount of canvas and paint; but I trust that the money will not be wasted.

Yesterday I witnessed a bull fight in which five men tormented the animal with banderillas and cockades. One of the toreadors was badly wounded while springing over a barricade. He was a fair man with blue eyes and displayed tremendous coolness. It was said that he had had enough for some time. He was dressed in light blue and gold, just like the three figures in the wood, in our picture "Le' Petit Cavalier," by Monticelli. The arena is superb when it is crammed full of men and the sun is shining.

This month will be hard for you and me; and yet if we can only see our way to doing so, it would be to our advantage to paint as many blossoming orchards as possible. I am now in full swing, and I believe I shall have to paint the same subject ten times over. You know that, in my work, I like variety; my passion for painting orchards will not last for ever. After them it will probably be the turn of the arenas. I also have a tremendous amount of drawing to do; for I should like to make drawings after the manner of Japanese crape prints.[33] For I must strike the iron while it is hot, and after the orchards I shall be completely exhausted, for the sizes of the canvases are, 32 in. by 24½ in., 36 in. by 27½ in., and 29 in. by 22½ in.[34] We should not have too many with twice the number; for I have an idea that these might break the ice in Holland.

Mauve's death was a hard blow to me, and you will notice that the pink peach trees were painted with some agitation.

I must also paint a starry night, with cypresses, or, perhaps, over a field of ripe corn. We get wonderful nights here. I am possessed by an insatiable lust for work. I shall be glad to see the result at the end of the year. I trust that by that time I shall be less tormented by a certain feeling of ill-ease that is troubling me now. On some days I suffer terribly! but I am not greatly concerned about it, for it is simply the reaction of the past winter, which was certainly not normal. My blood renews itself, and that is the most important thing of all.

My ambition is to make my pictures worth what I spend on them; or something more, because one must think of past expenses. But we shall succeed even in this; and even if everything does not turn out all right, work is at least progressing all the while.

I am constantly meeting the Danish painter; but he is soon going home. He is an intelligent fellow and his character and manners are impeccable, though his painting is still very weak. You will probably see him when he passes through Paris. You were quite right to visit Bernard. If he is going to do his military service in Algiers—who knows but what I may go to keep him company there.

I do believe that what K. says is quite right, I do not pay sufficient attention to values. But later on they will have even more to complain about, and they will say things that are no less true. It is impossible to attach the same importance both to values and to colours. Theodore Rousseau understood the mixing of colours better than any one. But time has blackened his pictures and now they are unrecognizable. One cannot be at the Pole and at the Equator at once. One must choose one's way; at least this is what I hope to do, and my way will be the road to colour.

If you think the picture "In Memory of Mauve" will pass muster, you ought to put it in a plain white frame and include it in the next batch of pictures you send to the Hague. If you should find among the other studies, one which you think would be suitable for T. you might send it too, without dedication, and then you could keep the study on which there is a dedication, and all you would have to do would be to scratch the words out. It is better to send him a picture without any dedication; for then if he should prefer not to have a picture of mine he can appear as if he did not know that we wished to present him with one and quietly send it back. In any case I must offer him something, just to prove that I am interested in the cause, and that I know how to value to the full the fact that he has taken it in hand. But, after all, do everything as chance ordains.... As Mauve and he were very great friends, in the excitement of the moment it seemed to me the most natural thing in the world to paint something for T. at the same time as I painted the picture "In Memory of Mauve." And that is all I thought about the matter.

Your Moslem notion that death comes when it must, might be looked into a little more deeply. It seems to me that we have no proof of such a distinct control of destiny by a power above. On the contrary, it strikes me that a reasonable and hygienic mode of life can not only lengthen existence but can also render it both merry and bright, whereas the neglect of hygiene in addition to disturbing the even course of our life may also bring it to a premature end. Have I not with my own eyes witnessed the death of a noble creature, simply because he had no intelligent doctor to attend him? He was so clear and so calm through it all, and kept repeating: "If only I had another doctor!" And he died with a shrug of his shoulders, and an expression on his face which I shall never forget.

I have been thinking of Gauguin and have come to the following conclusion: if he cares to come here, it will only cost him his journey and the two beds or two mattresses which we shall be compelled to buy. But, as G. is a seaman, we might perhaps be able to cook our food ourselves, and live together for the same sum as that which it costs me to live alone. You know that I have always thought it exceedingly foolish for painters to live alone; one always loses when one is quite isolated. You cannot manage to send him the wherewithal to live in Brittany, and me all that I need in Provence; but you might think it a good plan for us to share a common lot, and then you might fix a certain sum (let us say 250 francs per month) for which, in addition to my work, you would receive a Gauguin once a month.

Just a line in great haste to tell you that I have this minute received a note from Gauguin. He says that he has been too hard at work to write before, but is ready to come south at any moment, as soon as he can see the

possibility of so doing. They are having an amusing time over there, painting, discussing, and contending with the virtuous Englishmen. He speaks in high praise of Bernard's work, and B. is equally flattering about Gauguin's. I am now painting here with as much enthusiasm as the man of Marseilles eats his bouillabaisse, and this will not surprise you seeing that my subject consists of sunflowers. I have three pictures in progress: (1) Large flowers in a green vase; (2) Three flowers, two in the bud and one in bloom, on a royal blue ground; (3) Twelve flowers and buds in a yellow vase (the latter being light against light), will I hope be the best of the three. I shall probably not leave it at that. Pending the time when I shall share my studio with G., I should like to decorate it with a scheme consisting only of large sunflowers. In a restaurant near your shop (in the Boulevard Montmartre), there is, as you know, a beautiful decoration of this sort. In my mind's eye I can still see the great sunflower in the shop window before me. The whole scheme is to be a symphony of yellow and blue. I set to work every morning from daybreak onwards; for the flowers fade quickly and the whole thing must be done at one go. I have a host of ideas for new pictures. To-day I saw the same collier being unloaded by coal-heavers as that which I have already mentioned to you. At the same time I also saw vessels with cargoes of sand, of which I have sent you a drawing. That would be a splendid subject! But at present I am trying to discover a more simple technique which perhaps is not impressionistic. I should like to paint in such a way that everyone with eyes to see could not help but read a clear message from my pictures.

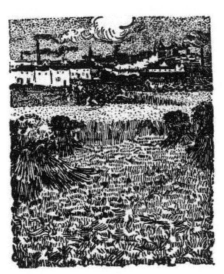

I have received a letter from G. in which he mentions the —— francs which you sent him and over which he was deeply touched. He also refers to your having made suggestions concerning our project (he had not yet received the definite proposal at the time of writing). He says that when he was with his friend L. in Martinique, he discovered that they were able to live more cheaply together than apart, and that he is quite convinced of the advantages of a joint establishment. His abdominal pains are as bad as ever, and he seems to be very sad. He hopes to be able to collect 600,000 francs with the view of founding an art-dealer's establishment for Impressionists, of which he will give you more explicit details; he also says that he would like to have you at the head of the undertaking. I should not be at all surprised if all this did not prove to be a Fata Morgana—castles in the air inspired by hunger. The greater one's straits for money—more particularly if one is ill besides—the more readily one thinks of possibilities of this sort. In this very idea, therefore, I seem to see the proof that he is broken down, and that he must be put on his legs again as soon as possible. He says that when seamen have to lift a heavy weight, or when they are weighing anchor, they all sing together, in order to increase their strength and to raise their spirits—and that is just what the artists do not do.

I should be very much surprised, therefore, if he were not glad to come here. But in addition to his hotel and travelling expenses, there will also be his doctor's bill to pay; so it will be somewhat difficult.

It seems to me that he will have to escape from the place with his debts, and leave pictures there as a pledge. I had to do the same thing in order to go to Paris; although I lost a heap of things on that occasion, one cannot do otherwise in such circumstances. For it is better to step forward than to stand still and rot. If G. prefers to run the risk of plunging into business; if he really hopes to achieve something in Paris, in Heaven's name let him go there! But I think it would be wiser for him to come here, at least for a year. I have seen some one here who came back from Tongking quite ill through his stay in that delightful country. But he has completely recovered his health here.

If you were to see La Camargue, and many other places in this part of the world, you would be as surprised as I am at the country being so exactly in the character of Ruysdael. I am at work upon a new theme: fields as far as the eye can see, both green and yellow. I have drawn them twice already and am beginning a picture of them. It is just in the style of a Salomon Konink—you know, the pupil of Rembrandt who used to paint those vast and endless plains—or of a Michel or a Jules Dupré. In any case it is something very different from rose-gardens. It is true that I have studied

only one side of Provence, and that on the other side nature has another aspect, such as Claude Monet used to render, for instance. I am really anxious to know what G. is going to do. He says that on one occasion he had 35,000 francs' worth of impressionist pictures bought by Durand-Ruel, and hopes to be able to do the same for you. In my opinion Gauguin's safest line of business would be the painting and sale of his own pictures.

I still have in my possession "A' Starry Night," "The' Furrows," "The Poet's Garden," "The' Vineyard." What! poetical landscapes? We will not attach too much importance to these studies, which, though the painting of them certainly cost one more in heart's blood than the others, are nevertheless not so marketable. If you had sent me 100 francs I should also have painted the sea at Saintes-Maries. The ruthless Mistral is now blowing, which is bad for work; but before real winter comes, we shall have some more fine weather, and in any case I hope to be able to add a few more studies to the series I now have in hand.

I can only finish a picture when it is framed.

The pitiless Mistral is blowing! but I have to keep myself constantly ready; for I have to paint during the short intervals and then everything must be in order for the battle to be fought. The canvas has not yet been sent, and the matter is most urgent. Do please order ten or at least five metres at once. It is pressing. To-day I bought some here in order, weather permitting, to be ready to-morrow or the day after. I am wholly absorbed in my work, and I will certainly not give in if only I can keep in the vein. All these large pictures are good, but very trying. Enclosed I send you a letter I wrote yesterday. In it you will see what I think of the portrait of G. which he has sent me. It is too black and too sad. Even so, I must confess that I like him. But he will change and must come here. One should not work Prussian blue into one's drawing of a face; for then it ceases to be flesh and becomes wood. I think and hope, however, that the other Brittany pictures are better, as regards colour, than this portrait, which after all was painted in a hurry.

Believe me, I exaggerate neither in regard to G. nor to his portrait. He must eat, take walks with me, see our house as it is, and give a helping hand,{GG} and, in a word, thoroughly divert himself. He has lived cheaply, it is true, but it has made him so ill that he can no longer distinguish a bright from a sombre tone. In any case it is exceedingly distressing, and it is

high time for him to come here, where he will soon get well again. Meanwhile, forgive me if I exceed my allowance; I shall work all the more for it. Since Thursday I have been so hard up that from then until Monday I had only two real meals. At other times I had only bread and coffee, which I had to have on credit and I paid for it to-day. If you can, therefore, send me something quickly.

This time things have gone pretty hard with me; I got to the end of my money on Thursday, and it seemed an age to wait until noon on Monday. During these four days I have lived principally upon 23{HH} cups of coffee, and the bread I ate with them is not yet paid for. That is not your fault but mine—if one speak of fault at all in the matter. For I was frantically anxious to see my pictures in their frames and had paid a little more than I could afford, more particularly as the month's rent and attendance had to be settled as well. As far as I am concerned, old chap, it would not matter, but I feel how you too must suffer under the stress which work imposes upon us; and my only consolation is to think that you would approve of my using every possible effort, so long as the fine weather lasts. I cannot say it has been fine for the last few days, as a ruthless north wind has been blowing and has driven all the faded leaves furiously before it. But between this and winter, the finest days and the most beautiful effects of light will come, and then I shall have to devote all my energies to my work. I am so much in the mood for painting that I simply could not stop suddenly.

Do you know how much I have left for the week, and after four days of fasting? Exactly six francs. I had something to eat at midday; but this evening all I shall have will be a crust of bread. And all my money is spent on the house and on the pictures. For I have not even got three francs left in order to.... {II}

One ought not to attach most importance to those studies which give one a great deal of trouble, and which nevertheless are not so pleasing as the pictures which are the result and fruit of those studies, and which one paints as if in a dream, without nearly so much trouble. Inclosed I send you a letter which I wrote a day or two ago on G.'s portrait. I have not the time to write it again; but I lay the most stress on the following points: I do not like all this ugliness in our work, save in so far as it shows us the way. Our duty is, however, neither to tolerate it on our own account, nor to make others tolerate it; on the contrary. I also send you herewith a letter from G.; fortunately he is getting well again. I should be extremely glad if R. were to

do something for him; still—R. has a wife, children, and a studio, and he is building a house; so I can well understand that even a rich man cannot always spend money on pictures, even if it were only a hundred francs. I believe it would be a great change for me, if G. were here, for day after day goes by now without my ever exchanging a word with a soul. In any case his letter was a great joy to me. If one live too long in the country, one gets quite besotted, and even if this has not happened to me yet, it might make me unproductive in the winter. This danger would vanish if he came, for we should never be at a loss for ideas. If work progresses favourably and courage does not fail us, we may reckon on a number of interesting years in the future.

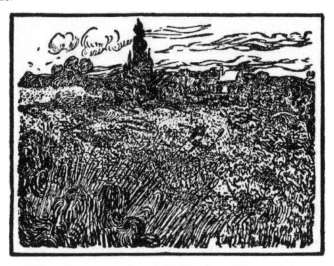

At the present moment I am holding an exhibition, for I have taken all my studies off their stretchers, and nailed them on the wall to dry. You will see that once I am in possession of a whole number of them, and a selection is made from them, it will come to the same thing as if I had lavished more work and study upon them; for whether one paint the same subject again and again on the same canvas or on several canvases does not make any difference to the seriousness of the work.

So our uncle is dead! Our sister wrote me the news this morning. They seem to have expected you at the funeral, so probably you were there. Life is short and vanishes like smoke! But that is no reason for despising the living. And we are right after all to think more of the artists than of the pictures.

M. K. returned here yesterday, and liked my pictures of the little girl and my garden. But I do not know whether he has any money. I am now busy painting a postman in a blue uniform with gold trimmings; he is a fanatical Republican like old T., and much more interesting than most people are.

If it were possible to call R.'s attention to it, he might perhaps take the picture by G. which you bought; and if there is no other way of helping G. what shall we do? I will say to him (R.): "Look here, our picture pleases you very much just as it is, and I believe we shall see even better work by this painter; why do you not do as we do? We believe in the man as he stands and like everything he does." And then I will add: "that, if it has to be, we shall naturally let him have the large picture, but that as G. is sure to be constantly in need of money, it would not be right for us in his interests to keep back the picture until his prices had risen three or four fold, which they are certain to do sooner or later." If R. then makes a plain and definite offer, we shall be able to consider it—and G. might say that although he had let you, his friend, have the picture at a certain price, he would not think of letting an art lover have it for the same sum. But let us first wait to hear what he will say.

The change that I am trying to introduce into my work is to attach more importance to the figure. In painting this is really the only thing which moves me to the depths, and which gives me a more vivid idea of infinity than anything else.

To-day I shall write to our sister; how sad they must be! As she herself says: "As soon as a man has left us, we can remember only his happy moments and his good points." And yet, the most important thing would be to see these things while he is living. It would be so simple, and would so enlighten us concerning the cruelties of life, which surprise us now and make our hearts so sore. If life had another invisible half, on which one landed when one died, we should then give those who started on this solemn and interesting journey our best wishes and our most hearty sympathy on the road thither.

I have just dispatched the large drawings: the upright of the small peasant garden seems to me the best. The garden with the sunflowers belongs to a bathing establishment. As to the third garden, which is landscape shape,[35] I have also made oil sketches of it. The orange-coloured, yellow patches of flowers grow exceedingly brilliant under the blue sky, and everything is bathed in a happier and more loving atmosphere

than in the north: it vibrates, like your bunch of flowers by Monticelli. Although I have done about 150 drawings and oil-sketches I feel as if I had done absolutely nothing. I would readily content myself with being a precursor of the painters of the future who will paint here in the south.

There are a number of fine lithographs to be seen: Daumiers, reproductions of Delacroix, Decamps, Diaz, Rousseau, Dupré, etc. Soon, however, this will cease, and what a pity it is that this art is about to disappear!

Why do we not stick to what we have once discovered in our art, as the doctors and the engineers do? With them, when anything is discovered, the knowledge of it is carefully preserved. But in the wretched fine arts everything is forgotten; we hold fast to nothing. Millet created the synthesis of the peasant, and now? Oh, of course, there are Lhermitte and perhaps one or two others as well—Meunier, for instance. But have painters really learnt to see a peasant in the proper way? Not at all! Scarcely one of them is capable of such a thing. And does not the fault lie a little with the Parisians, who are changeable and deceptive as the sea? You are quite right in saying that we must go our own way, quite unconcerned, and work for ourselves. Do you know that even if Impressionism were sacrosanct, at times I should, nevertheless, like to be able to paint things which the former generation, Delacroix, Millet, Rousseau, Diaz, Monticelli, Isabey, Decamps, Dupré, Ziem, Jonkind, Israels, Mauve, and a host of others, Corot, and Jacques ... would be able to understand.

Manet and Courbet got very near to treating colour and form together as equal in importance. I should like to prepare myself for ten years by means of studies for the task of painting one or two figure pictures. The old and eternal plan—so very often recommended and so seldom carried out!

The small upright of the peasant garden, as I saw it in nature, is glorious in colour. The dahlias are a deep and severe purple, and on one side there is a double row of flowers which is a mass of pink and green, and on the other there is a mass of orange with scarcely any green. In the centre there is a low white dahlia and a small pomegranate tree with greenish yellow fruit, and blossom of an ardent orange red colour. The ground is grey, the tall reeds are blue green, the trees viridian, the sky blue, the houses white with green window frames and red roofs. That is how it looks in the morning in full sunlight; at evening it is all immersed in the deep shadows

cast by the fig trees and the tall reeds. That is the whole thing. To seize all these beauties, a whole school of artists would be necessary, who would work together and complete one another in the same country, like the old Dutchmen: portrait painters, painters of genre pictures, landscapists, animal painters, painters of still-life, etc.

I have now received the two portraits. In B's portrait of himself a portrait of G. hangs on the wall, and in G's. portrait of himself there is a portrait of B. in the background. At first one can only see G.; but B's. picture appeals to me very much indeed too.

It is only a painter's idea, only a few summary tones and a few black lines; but it is as *chic* as a genuine Manet. The G. shows more study and is more carefully carried out, and that is exactly what makes one feel as if it were the representation of a captive. It shows no trace of good cheer, no particle of flesh; but all this may be ascribed simply to his intention, which was to produce something melancholy. Those parts of the skin which are in shadow are a sombre blue. Now at last I have the opportunity of comparing my painting with my friends'. There is no question that my portrait which I am sending to G. in exchange for his, holds its place quite well beside the latter. I wrote to G. that if I might be allowed to lend unmerited importance to my personality in a picture, I had tried to paint, not exactly myself, but the portrait of an impressionist, and had therefore conceived this picture as that of a bonze in abject adoration before his great Buddha. And when I place my conceptions and G's. side by side, I find mine just as serious as his but not so full of despair. And G's. portrait seems to say to me: this must go on no longer, he must grow contented again, he must become the old G. of yore, who meanwhile has grown richer, through the south{JJ} and the negresses.

I am extremely glad that I have the portraits of our friends at this period. They will not remain as they are; in time they will have a cloudless life, and I feel plainly that it is my duty to do everything in order to reduce our poverty. Poverty is impossible in our profession. I feel that he is more like Millet than I am, but I am more like Diaz than he is.[36] And like Diaz I will try to please the public in order to help him. My work has cost more than theirs; but I do not mind this now that I have seen their painting; they worked amid too much poverty to have success; for, believe me, I have better and more saleable work than that which I sent to you, and I feel that I am capable of even better things. I feel quite confident that there are many people to whom the poetical subjects in particular will appeal. The "Starry' Sky," the "Vine-Branch," the "Furrows," the "Poet's Garden." For I consider it our duty, yours as well as mine, to aim at comparative wealth,

as we shall have great artists to provide for. If you have Gauguin, you can be as happy as Sensier. He will be so pleased with the house as a studio, that he will even want to rule and manage it. B. has sent me a collection of ten drawings.... You will soon see all these things; but I shall keep the portraits by me, and enjoy them for a little while longer, before I send them to you. Some day you will probably see the portrait of myself which I sent to G., for I hope G. will keep it: it looks quite ashen-grey against a pale emerald green (not yellow) background. I am wearing the brown jacket with the blue edging. I intensified the brown to a purple, and I broadened the edging. The head is modelled entirely in light colour, light on a light ground, almost free from shadows; but I have painted the eyes somewhat oblique, *à la japonaise.*

Letter from G.... who tells me that he has sent you a batch of pictures and studies. I should be very glad if you could find the time to write me a few details about them. With G's. letter I also received a note from B. in which he confirms the receipt of my pictures, all seven of which they mean to keep. B. is making me a present of one more study in exchange, and the three others, M., L., and another young painter, will, I hope, also send portraits. G. has my portrait and B. writes that he would very much like to have one in the same style, although he already possesses one which I gave him in exchange for his portrait of his grandmother. And I was glad to hear that they were not displeased with my figure pictures.

I have been and still am half dead, after my last week's work. I cannot do anything yet but, as it happens, a terrific north wind is blowing at present, which whirls up clouds of dust and covers the trees from top to bottom in a coat of white. Willy-nilly, therefore, I am obliged to remain idle. So I have slept sixteen hours at a stretch; it has done me a tremendous amount of good, and to-morrow, thanks to this thorough rest, I shall be well again. But I have a good week behind me: five canvases are no small matter; if one suffer a little for that sort of thing it really is no wonder. If I had worked more slowly, however, the storm would only have interrupted me. When the weather is fine one should take advantage of it, otherwise one can make no headway.

What is Seurat doing? If you see him, tell him that I have a scheme of decoration in view which, as far as I can tell at present, will extend to fifteen pictures, and which, in order to be complete, will require another fifteen.

Tell him also that I am encouraged in my labours upon this serious scheme by recollections, not only of his own good self, but also of the fine large pictures which I saw in his studio.

❖

We ought also to have a portrait of Seurat by himself.

I wrote to G. that when I suggested an exchange of portraits between us, I had naturally taken it for granted that he and B. had made studies of each other; and that as this did not prove to be the case, and that he had painted one specially for me, I could not accept this picture in exchange, as I regarded it as too important a work of art for the purpose. Nevertheless, he replied that I absolutely must accept it in exchange, and his letter contained a host of compliments which, as they were undeserved, I pass over.

❖

I am sending you an article about Provence which, in my opinion is well written. The "Félibres" are a literary and artistic society, composed of Clovis Hugues, Mistral, and others, who write excellent sonnets in the Provençal dialect and in French. If ever the "Félibres" deign to take any notice of me here, they will all come into my little house. But I should like this to occur only when I have finished my decorations. As I love Provence just as whole-heartedly as they do, I feel that I have some right to their consideration. If ever I avail myself of this right, it will be in order that my pictures may remain here or in Marseilles, where, as you know, I should like to work. For the artists of Marseilles would do well to continue the work begun by their fellow-townsman Monticelli. If G. or I were to write an article for one of the local papers here, it would suffice to open up relations with them.

I must tell you that I have made a very interesting expedition through various local farm properties, in the company of some one who knows this part of the country very well. They are all small peasant holdings, à la Millet, translated into Provençal. M. K. and B. cannot make head or tail of it all, and even though I am beginning to feel a little clearer in regard to it all, I should have to live here a jolly long time in order to be able to paint it.

❖

I often feel that the only possible way of carrying out our plan will be for me to set out on a journey, in case Gauguin does not succeed in escaping from the place. And, then, after all, I should still remain with the peasants. I even believe that we should hold ourselves in readiness to go to

him; for sooner or later he is sure to be in dire distress, if, for instance, his landlord refuses to allow him any more credit. This is more than probable, and then his need might be so great, that our plans would have to be carried out with all possible dispatch. As far as I am concerned the only expense would be my journey thither; for, according to him, the cost of bare necessaries is much lower there than it is here.

People are better off in this place than in the north, even when they are quite hard up. For the weather is always fine, and the Mistral itself makes no difference to it. That glorious sun, in the rays of which Voltaire used to bask while sipping coffee, continues to shine notwithstanding. In all directions one is reminded quite involuntarily of Zola and Voltaire. There is such an abundance of vital energy everywhere. It is like Jan Steen and Ostade's work. The conditions for the formation of a school of painting are certainly to be found here. You will reply, however, that nature is beautiful everywhere, if only one enters sufficiently deeply into her spirit.

Have you read "Madame' Chrysanthème," and made the acquaintance of Monsieur Kangourou, that pander, so overwhelmingly obliging, with the sugared spices, the fried ices, and the salted sweetstuffs?

I have seen a wooden figure of a woman, in a peasant garden here, which came from the prow of a Spanish ship. It stood in the midst of a group of cypresses, and the whole effect was very like Monticelli. Oh! what a lot of poetry there is in these farm-gardens, with their abundance of lovely red Provençal roses, these vineyards, these fig trees, and the perennially powerful sun, in spite of which the green of the vegetation remains so fresh! There are also the reservoirs with their clear water running over the orchards through diminutive channels which constitute a regular canal system on a small scale; and the old grey horse of "la Camargue" which sets the machine in motion. No cow is to be found in these farmyards. My neighbour and his wife (who are grocers) are extraordinarily like the Buteaux. But in these parts the peasant holdings, the inns, and even the lowest cafés, are less gloomy and less tragic looking than they are in the north; for the heat makes poverty less cruel and less lugubrious. I wish to Heavens you had seen this country! But our first concern must be to await developments in Gauguin's quarter.

Gauguin responded to the call of his friend and came to join him in his work in sunny and gay-coloured Provence. A fit of insanity, however,

seized Van Gogh and broke up the companionship of the two artists. From that time onward, Van Gogh lived in an asylum, where in his moments of lucidity he was still able to paint beautiful pictures.

Concerning the last days of his friend, Gauguin writes as follows: "In his last letter from Auvers, near Pontoise, he said that he had always hoped that his health might so far improve as to permit him to paint with me in Brittany, but that he was then convinced that recovery was out of the question. 'My dear master, after having known you and grieved you, it is more dignified to die while I am fully conscious of what I am doing, than to take leave of this world in a state which degrades me.' He fired a bullet at himself, and, a few hours later, while lying in bed smoking his pipe, with all his wits about him, full of passionate love for his art, and without any feelings of resentment towards humanity, he quietly passed away."

NOTES

{A} page 39. The translation of the original French would be: "without having recourse to the old dodges and delusions of intriguers" (*aux vieux trucs et trompe-l'œil d'intrigants*).

{B} p. 44. The French is *boutons d'or* (buttercups). The German translation has *Löwenzahn*.

{C} p. 45. The German is, *Leute die auf Technik sehen*; but my rendering is more faithful to the French original.

{D} p. 51. According to the French this should be: "After many eccentricities you have succeeded in producing," etc. The German, however, is, *wirst Du dahin gelangen Sachen von ägyptischer Ruhe*, etc.

{E} p. 55. The French word is *bestiales*, which the German translator rendered by *grausame*.

{F} p. 55. The French is *crâne* (swaggering); the German translation has *elegant*.

{G} p. 60. The French has, *your* grandmother.

{H} p. 61. The French is, *amours faciles*.

{I} p. 62. The French is, *senti dans son animalité*.

{J} p. 62. From this point the original French continues, "is like the consummation of sexual love—a moment of infinity."

{K} p. 63. In his original publication of these letters in *Le Mercure de France*, E. Bernard inserts a note here to the effect that Van Gogh meant that Rembrandt used religious subjects only as a means of expressing philosophical ideas.

{L} p. 64. The French is, *peint un ange surnaturel au sourire à la Vinci*.

{M} p. 65. The French is, *folie contagieuse*.}

{N} p. 66. The French is, *sincérité et dévotion*.

{O} p. 68. The German translator took what I believe to be a justifiable liberty here; for the original French reads: *et il sagit de souffler de son souffle tant qu'on a le souffle*.

{P} p. 73. The French word is *renaissance*.

{Q} p. 74. The German translation (*beim Fechten*) misses the point here; for the French original is not *l'escrime*, but *l'escrime à l'assaut*.

{R} p. 77. In the German translation there are no dots here to show that a passage has been omitted; as however, this passage seems to me important, I thought it advisable to give the translation of it in these notes. After the word "nature," the French original proceeds: "in order to convert a study into a picture by arranging the colour, adding here, and simplifying there;..."

{S} p. 81. E. Bernard says that this refers to a caricature by Gauguin of Van Gogh sitting on a ledge of rock drawing the sun.

{T} p. 83. The French word is not *talent* but *supériorité*.

{U} p. 89. I confess that I did not understand the proper meaning of this passage, either in the French or in the German, so here it is, as it stands in the French original: *Mais justement à cause de ce que c'est dans le cœur des gens qu'est aussi le cœur des affaires, il faut conquérir des amitiés ou plutôt les ranimer.*

{V} p. 90. It may be of interest to painters to know that the other colours mentioned in the French original are: *rose de garance*, and *mine orange*.

{W} p. 96. I may be wrong here. The German word is *Axiomen*, the French original is, *axiomes*.

{X} p. 98. The French original contains simply the word *sérénité*, which the German translator paraphrased as "the joy of living, and peace."

{Y} p. 101. The French original has, *on ne s'en repent pas*, in the place of "one can never cast it out."

{Z} p. 102. It is not clear whether Van Gogh meant that he opposed the firm B. and V. or that he quelled the feeling in his heart. The French original is simply: *Seulement je m'y oppose.*

{AA} p. 104. The French original is, *des établissements pour Zouaves.* On this point see also p. 23, vol. 12, of the "Mercure de France."

{BB} p. 108. The original reads: *Si je me laissais embêter par le premier venu ici, tu comprends que je ne saurais bientôt plus où donner la tête.* The German rendering was therefore a little too free.

{CC} p. 116. A passage is omitted here in the German translation, which I think is of sufficient interest to be quoted. In the French original the passage reads: *Je crois que Gauguin lui-même souffre beaucoup et ne peut pas se developper comme pourtant c'est en dedans de lui de pouvoir le faire.*

{DD} p. 116. On both occasions when in the German text I found the word *Schwefelgelb*, I translated it by "cadmium." The word in the French original is simply *soufre*. (See also page 73.)

{EE} p. 122. The German word is *Quadratnets*, and the French original has *cadre perspectif*. I am not sure that my rendering gives an adequate idea of the instrument.

{FF} p. 124. The French is, *rhinocéros dangereux.*

{GG} p. 145, "and give a helping hand," is a somewhat free rendering, through the German, of *et comme nous le ferons.*

{HH} p. 146. The number "28" seems to be a misprint in the German.

{II} p. 147. E. Bernard, himself, leaves one to guess at what this means; for in the original French we read: *Car je n'ai même pas, depuis un mois trois semaines, de quoi aller ... pour 3 fr.*

{JJ} p. 154. In the French original there is no mention of "the south."}

FOOTNOTES:

[1] 1 See "Mercure de France," vol. 48, p. 127 (Oct. 1903), Article, "Paul' Gauguin," by Charles Morice.

[2] "Mercure de France," vol. 48 (Oct. 1903), p. 127.

[3] That Vincent also often felt depressed about his work may be gathered from the following passage, taken from a letter to his brother, not included in this volume: "C'est une perspective assez triste de devoir se dire que jamais la peinture que je fais n'aura une valeur quelconque."

[4] See Emile Bernard's preface to his publication of Van Gogh's letters in the "Mercure' de France," vol. 7, p. 324.

[5] As to how he overcame his academic period, see Meier Graefe's work, "Impressionisten" (p. 122) where the author has some interesting things to say.

[6] "Mercure de France," vol. 48 (1903), p. 105.

[7] The italics are mine.—A. M. L.

[8] Not included in this collection of letters.

[9] I could not discover who the owner was; but the present number of the exhibit is 984F and the picture is marked "*In Bruikleen*" = lent.

[10] I have reasons to believe that this wonderful picture was sold by the Sonderbund people at the very time of my visit to Cologne for the sum of £450. But I was unable to discover the name of the new owner.

[11] See particularly his picture No. 1105 at the Ryksmuseum, Amsterdam.

[12] I wonder if it is to this work that Gauguin refers when, speaking of the progress Van Gogh was making under his tuition, he asks Morice: "Avez-vous vu la gure et les cheveux, jaune de chrome?"

[13] "Mercure de France," vol. 48 (1903), p. 127.

[14] Ibid., p. 129.

[15] Both belonging to Galerie E. Druet in 1911.

[16] Belonging to Bernheim Jeune in 1911.

[17] "Mercure' de France," vol. 13 (1895).

[18] "Impressionisten," p. 128. By-the-bye, Meier Graefe does not say why he thinks this, nor does he reveal the source of his judgment.

[19] "Mercure' de France," vol. 48, p. 126.

[20] At Amsterdam. The picture here referred to, which, as far as I was able to judge, measured 10 in. by 6 in., represents a monk seated by the side of a sick or dying man's bed.—Tr.

[21] A word suggesting bold virtuosity in expressing an impression.—Tr.

[22] The German is *wanzenartig*, but the above rendering gives, I think, a better idea of Van Gogh's meaning than a literal translation would.—Tr.

[23] Van Gogh must be referring, here, to Japanese prints which have undergone a process of craping. For details of this process see "Japanese Colour Prints" by E. F. Strange (pp. 110, 111).—TR.

[24] This sentence does not seem to make sense, even in the French, without this interpolation.—Tr.

[25] The writer is undoubtedly referring to the St. Matthew in the Louvre.

[26] In the Middle Ages these were corporations consisting of all people engaged in the writing and general production of books, as at Antwerp, for instance. These guilds, which in other places, as at Bruges, were also called St. John Guilds, were often joined by the first printers, until their numbers in any particular town allowed them to form a guild of their own.—Tr.

[27] The German is "No. 30 Quadrat," which is rendered approximately by the above.—Tr.

[28] German "No. 30."—Tr.

[29] The German is: *zwei Bilden in Breitformat*. The only English term which appears to be used to designate a picture the horizon line of which runs parallel to the longest sides of the canvas, and which is therefore the reverse of an "upright," is "landscape-shape."—TR.

[30] See note on p. 40.

[31] See note on p. 91.

[32] Ger. "No. 15."—Tr.

[33] See note, p. 40.

[34] These figures are approximate only. The German equivalents are Nos. 25, 30, and 20.—Tr.

[35] See note p. 91.

[36] Reference to Diaz's self-sacrificing friendship for Millet.

Lightning Source UK Ltd.
Milton Keynes UK
UKHW010745271222
414464UK00004B/293